The Bicycle

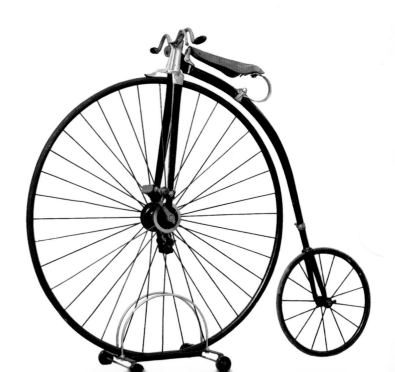

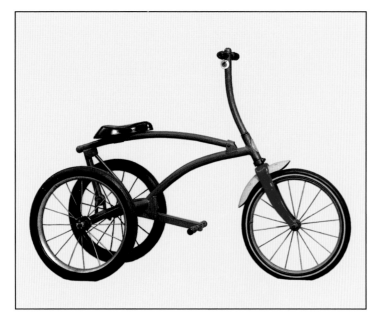

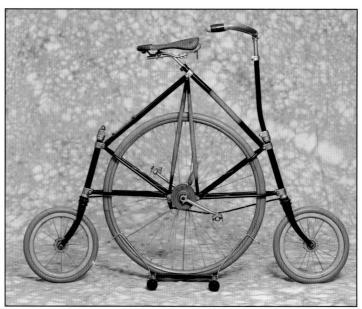

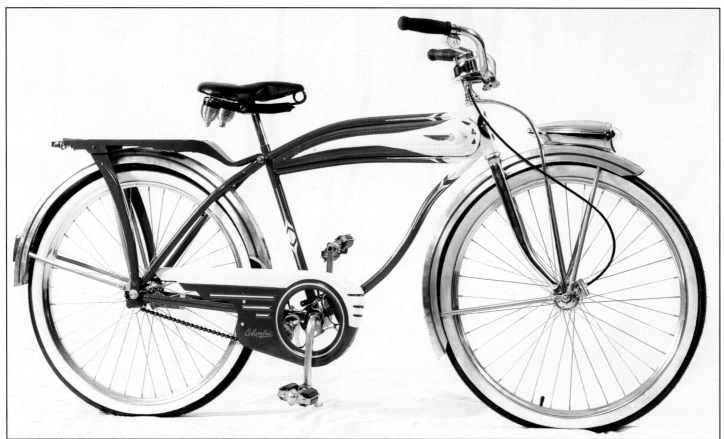

The Bicycle

Boneshakers, Highwheelers, and Other Celebrated Cycles

by Gilbert King

COURAGE
BOOKS
AN IMPRINT OF RUNNING PRESS
PHILADELPHIA • LONDON

© 2002 by Running Press

All rights reserved under the Pan-American and International Copyright Conventions

Printed China

All photographs © 2002 by Gilbert King

9 8 7 6 5 4 3 2 1

Digit on the right indicates the number of this printing

Library of Congress Cataloging-in-Publication Number 2001094063

ISBN 0-7624-1262-3

Cover and interior design by Corinda Cook

Edited by Molly Jay and Joelle Herr

Typography: Esprit, Script, and Univers

This book may be ordered by mail from the publisher.

But try your bookstore first!

Published by Courage Books, an imprint of

Running Press Book Publishers

125 South Twenty-second Street

Philadelphia, Pennsylvania 19103-4399

Visit us on the web!

www.runningpress.com

Acknowledgments

The author would like to profusely thank David Metz of the Metz Bicycle Museum in Freehold, New Jersey, for his invaluable help throughout this project. Mr. Metz proved to be a priceless resource and his breadth of knowledge regarding early bicycle history and engineering was a bonus for my research. He was also extraordinarily patient and cooperative in letting me photograph his collection over many days. I would also like to thank Bina Altera for her tireless photographic assistance. Among the many books used as source material for this book, several stand out as particularly useful: Pryor Dodge's magnificent book, *The Bicycle*; Andrew Ritchie's *King of the Road*; Arthur Judson Palmer's *Riding High: The Story of the Bicycle*; G. Donald *Adams' Collecting & Restoring Antique Bicycles*; Robert A. Smith's *A Social History of the Bicycle; Discovering Old Bicycles* by T.E. Crowley; and Jay Pridmore and Jim Hurd's *The American Bicycle*. I would also like to thank my editor, Molly Jay, at Running Press for her diligence, guidance and editorial expertise, as well as Carlo De Vito, the Associate Publisher of Running Press and resident of Freehold, who came up with the idea for this book.

Dedication

Collecting antique bicycles has always been a passion of mine. For over fifty years my family has encouraged me to pursue my hobby and for that I am extremely grateful. I would especially like to thank my wife Sadie for her sixty years of love and devotion. She has always taken an active interest in my hobby and has encouraged me to buy some of my most rare and unusual bicycles. Sadie was a great inspiration in helping me fulfill my dream of establishing the Metz Bicycle Museum. My three children, Martin, Lorraine, and Larry have grown up embracing my passion—sharing my enjoyment with each new acquisition as well as participating in parades and bicycle meets. My nine grandchildren have had great fun riding the bikes, some of them taking part in local parades and each of them hosting a class trip to see my collection. Their enthusiasm has brought me great pleasure. Now I look forward to having my great grandchildren become the fourth generation to enjoy my bicycle collection. Having people to share a hobby with is one of the most enjoyable parts of collecting, and when these people include your own family, it is even more rewarding. I dedicate this book to my entire family.

David Metz

Contents

Introduction

One of the questions people ask me most often is "How did you ever get started collecting antique bicycles?" I tell them that I was born and raised on a farm, and that working with machinery was always a part of my life. If a mowing machine or potato digger broke down, there was no mechanic to call. We had to fix it ourselves. I always enjoyed figuring out how things worked and how to fix them, and I guess this helped create my interest in early mechanical things, especially bicycles.

As a young child, I remember working hard on the farm to save enough money for my first bicycle. I don't remember the name or make, but I do recall learning to ride it backwards while sitting on the handlebars. If anything ever broke on that bike, I had to fix it myself, and that helped me learn and become fascinated with the mechanical aspects of bicycles. One of my strongest memories as a child was getting a flat tire on that bike, and having to save my money for months before I had enough to get it fixed.

In the early 1940's, I married my wife, Sadie, and we had three wonderful children. I decided that it was time to get out of farming and into another business. The farming area of central Jersey was just beginning to experience a building boom, and I decided to get into the manufacturing of concrete building blocks. Once again, this involved a great deal of involvement with machinery, trucks, and mechanical equipment. Shortly thereafter, we bought our home in Freehold, New Jersey—an old farm site from the 1880's, complete with two large barns and

an outhouse. When we bought the home I never imagined that those barns would be a perfect area for my future antique collections.

In the little bit of spare time that I had, I enjoyed going to flea markets, antique shows, and auction sales, especially if I knew that there were old bicycles for sale. The very first bicycle in my collections was an 1897 girl's bicycle that I purchased in Pennsylvania for forty dollars. I still have that bicycle in my collection today and don't think I will ever part with it. Little by little I started to accumulate more and more of what my family referred to as "junk."

My bicycle collection really took a leap forward in the early 1960's when I heard about a collection of old bikes that was for sale in Massachusetts by a man named "Lucky" Theibolt, a motorcycle stunt rider who entertained in country fairs and circuses. I flew up to see his collection and ended up renting a truck to drive home with about 30 bicycles, most of which I still have today.

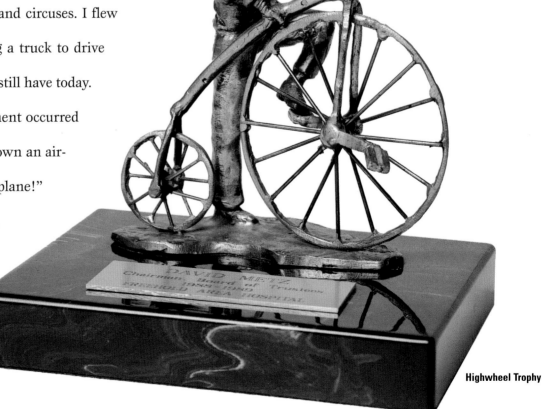

Highwheel Trophy

Perhaps my most dramatic collecting moment occurred in the 1970s, when I found myself running down an airport corridor, shouting, "I have to get on that plane!" A 727 was already taxiing toward the runway, but miraculously, an airline attendant radioed the tower and the jet returned to the gate. I'm pretty sure I know what the reaction

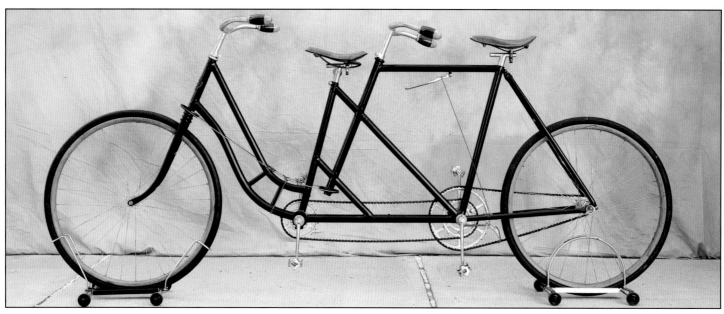

(Top) 1901 Wolff American Tandem steers from the front and rear. Notice the brake handle under the rear top bar and the very sturdy frame construction.

(Bottom left) Deluxe Ranger, made by Meade Cycle Co., Chicago IL. Complete with horn tank, headlight, claxon horn, air pump, rear carrier, rear wheel stand and front fork truss bars.

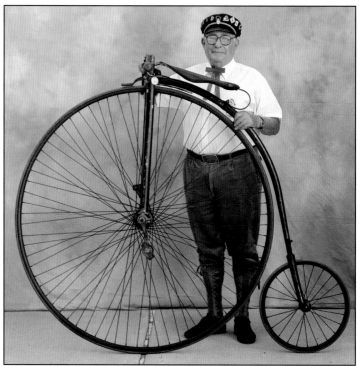

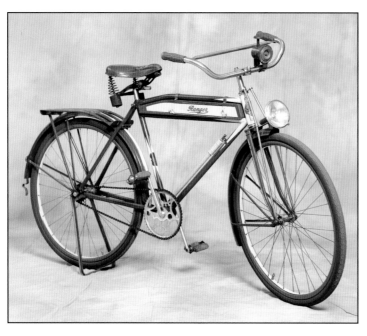

(Bottom right) 1885 52-inch New Rapid Highwheel bicycle. Tangential spoking crosses over eight spokes and is wire wrapped and soldered at two points. This gives much added strength and sturdiness to the wheel. This is my personal sturdy old steed that I have ridden for over thirty-five years.

would have been had the passengers known the reason for the delay. Once another bicycle—an unusually rare four-wheeled quadricycle made in 1850—was for sale in Sarasota, Florida. I never told anyone what I paid for that quadricycle, but the acquisition brought my collection to another level, and in 1976 at the convention of the Wheelmen, a national bicycle collectors organization, my new quadricycle garnered three major awards.

As my collection of bicycles grew, I ran out of room to display everything. In 1999, I opened The Metz Bicycle Museum and Treasures of Years Gone By in downtown Freehold, New Jersey. Collectors from around the world, museum curators, and everyone who visits the museum have agreed that it is one of the finer collections of antique bicycles in the world. I personally feel that a hobby, no matter what it is, is one of the greatest forms of relaxation. You enjoy meeting many interesting people, sharing information and stories with them, and helping to preserve the history of bicycles for future generations. I have enjoyed the hobby for close to fifty years and hope that this very rare collection will be preserved for future generations to enjoy when they visit The Metz Bicycle Museum.

David Metz

Freehold, New Jersey

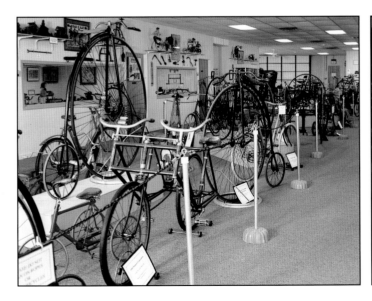 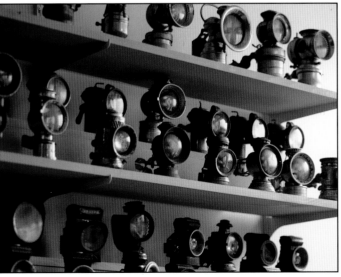

The Metz Bicycle Museum, Freehold, NJ.

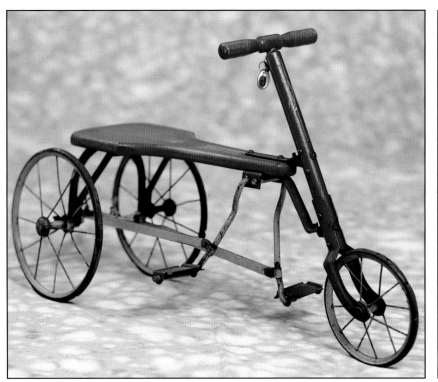

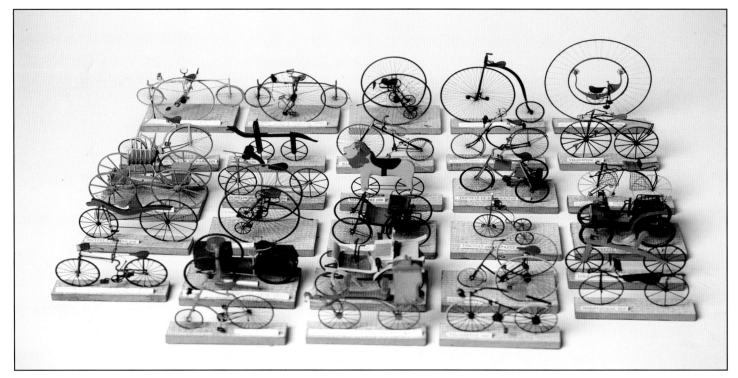

The Beginnings

Unfortunately for historians, the very first bicycle was not unveiled in some grand ceremony or presentation, with the inventor hopping aboard and pedaling around a village to the astonishment of onlookers who were certain their lives would never be the same. Rather, the bicycle appeared as a work in progress—an evolution in design over decades, (some would say centuries or even millenniums) ultimately leading to a contraption that would indeed change the way people lived all over the world. In tracing the steps of this evolution, it is important to come to some understanding about man-powered mechanical vehicles. Some researchers point to the tombs of Egypt and frescoes of Pompeii, where intimations of bicycles can be found. Others suggest that Roman battering rams on wheels were important links in the chain of the bicycle's evolution. Illustrations of large, four-wheeled apparatus appeared in old books, one engraved by Albrecht Durer in 1520. A stained glass window at the St. Giles church in Stoke Poges, England, dated from 1642, depicts a trumpeting male seated in a saddle with a wheel to what looks like some type of bicycle. An enhanced depiction of this stained glass image, this time with two wheels, was widely published without question, despite the variation from the original. Even drawings, done possibly by an assistant to Leonardo da Vinci or Leonardo himself in 1493,

seem to depict some early version of the bicycle, with two spoked wheels, a drive chain and a cogwheel. Leonardo's drawing's authenticity has been called into question of late, however.

Rather than succumb to the ambiguities of pinpointing the invention of the wheel and its relationship to the bicycle, let us focus on the definition of a bicycle as a man-propelled vehicle designed for transportation. Using this definition, a more consistent pattern of invention and exploration emerges, and it becomes clearer to define how and when the bicycle, as we know it today, developed.

In the mid-seventeenth century, coachmakers were experimenting with carriages that did not rely on horses. Jean Hautsch of Nuremberg (1595–1670) was a German inventor who made a four-wheel carriage for the Prince of Sweden in 1663. In fact, it is believed that Hautsch used the designs from Giovanni Fontana, the Rector of the Faculty of Arts at Padua at around 1418. Fontana drew up plans for a four-wheeled vehicle that advanced when the

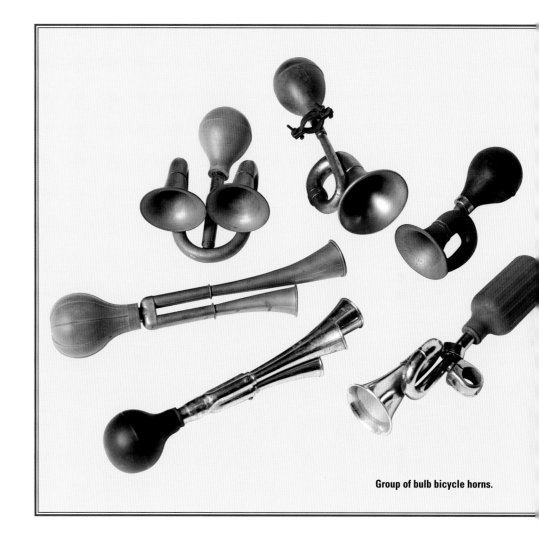

Group of bulb bicycle horns.

driver tugged a loop of rope strung around a pulley which turned the rear wheels through a gearing system.

However, the "Hautsch" four-wheel carriage was apparently rear-propelled by handles inside the carriage, while the "driver" steered two smaller wheels in front. The French also appeared to have a

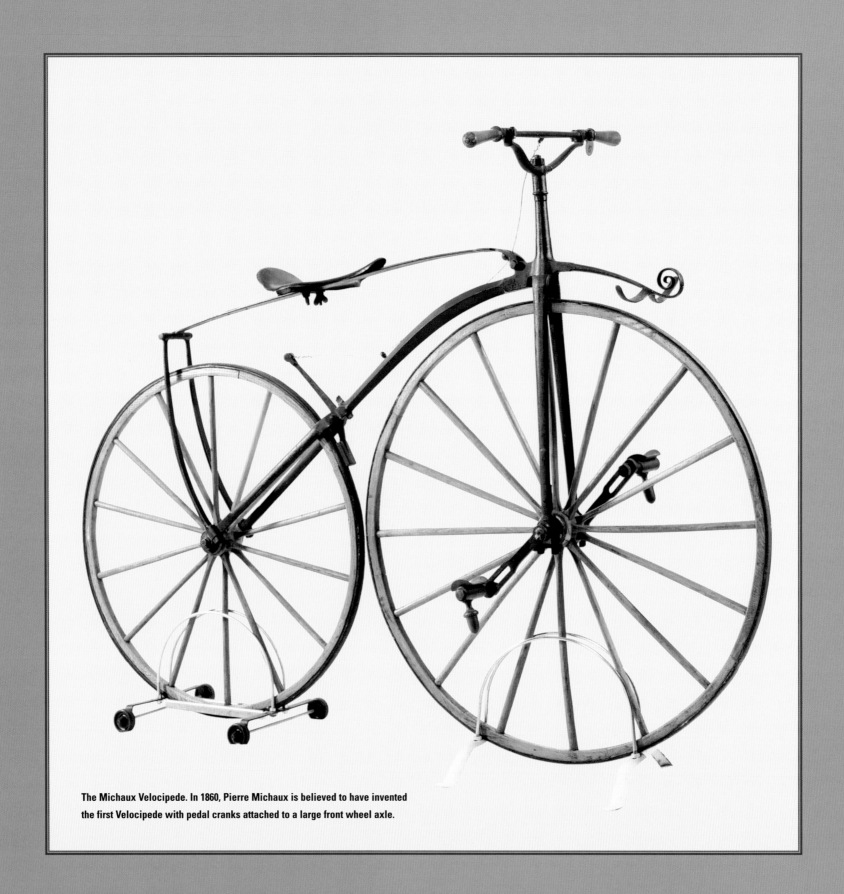

The Michaux Velocipede. In 1860, Pierre Michaux is believed to have invented the first Velocipede with pedal cranks attached to a large front wheel axle.

similar carriage in existence, driven by two men. But these carriages did not replace horse-drawn carriages, as they were extraordinarily slow, cumbersome and more novel than practical. Still, they represented the earliest documented attempts at designing self-propelled vehicles.

By the end of the seventeenth century, coach-makers began experimenting with smaller and lighter carriages. Hand-cranks and arm-turned systems gave way to foot pedals, as inventors quickly learned that the application of body weight through the use of one's legs was a far more efficient source of energy. Dr. Elie Richard of France invented a carriage at the end of the century that required one man to sit beneath the canopy and steer while the second man stood toward the rear of the carriage, bouncing up and down on a cranked rear axle which powered the coach. The machine, though lighter and smaller than many predecessors, was difficult to maneuver uphill, and a braking system was non-existent, rendering the vehicle vulnerable to the dangers of a downhill cascade! Still, Dr. Richard became a fixture on the streets of Paris for several years in his man-powered carriage.

As much promise as these carriages showed, nearly a hundred years would pass before much progress was made in making these vehicles more rider-friendly. In 1761, an Englishman by the name of Ovenden put together a carriage similar to Dr. Richard's, but, according to *Universal Magazine* of the same year, the vehicle is:

"... doubtless the best that has hitherto been invented, as it is capable of traveling with ease six miles an hour, and by a particular exertion of the footman, might travel nine or ten miles an hour on a good road, and even go up a considerable hill where there is a sound bottom. But this carriage is in general only calculated for the exercise of gentlemen in parks or gardens for which it answers extremely well."

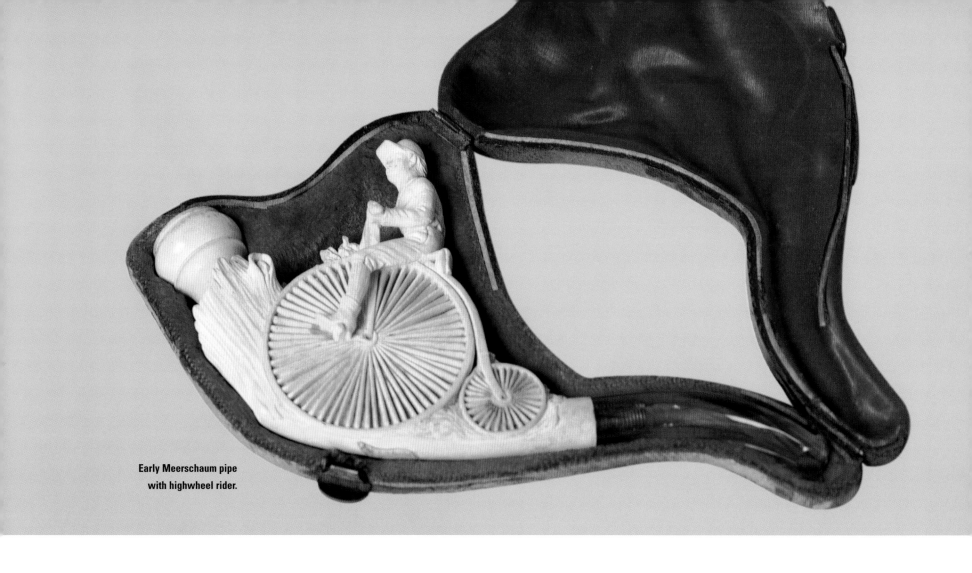

Early Meerschaum pipe
with highwheel rider.

Almost ten years later, a Parisian carriage designer and inventor by the name of M. Blanchard demonstrated his version of the self-propelled carriage, first in Paris and Versailles, and later on in Philadelphia, where he claimed to have given the great American inventor, Benjamin Franklin, a ride. Blanchard boasted of being able to drive his carriage up the ramp in front of the opera at Versailles, "which is impossible even for the best horses."

In 1765, Comte de Sivrac, a French nobleman, was alleged to have introduced a two-wheeled contraption called a *velocefere*. It was, according to legend, supposed to have a wooden frame and resemble a children's hobbyhorse—popular at the time, and de Sivrac was said to have demonstrated the vehicle for Marie Antoinette at Versailles. The story originated in L. Baudry de Saunier's *Histoire General de la Velocipedie,* published in 1891. However, the story

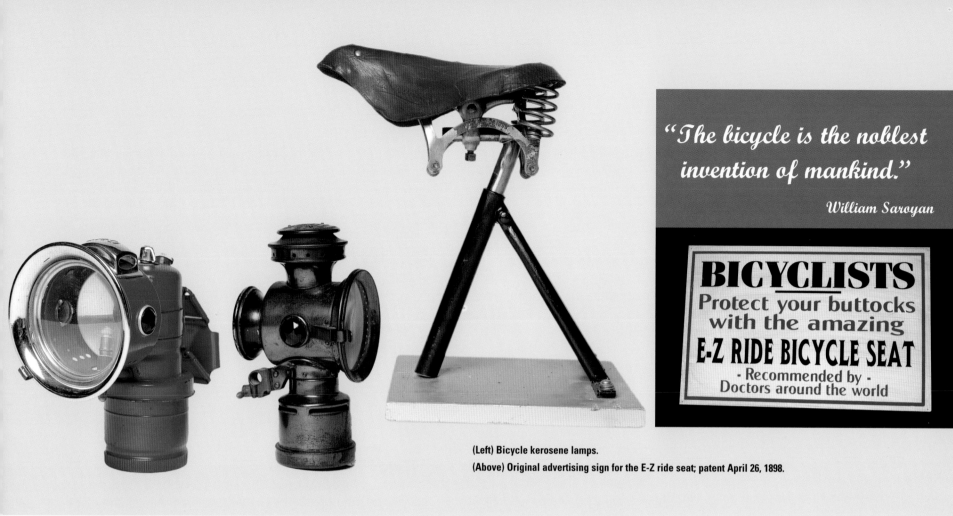

(Left) Bicycle kerosene lamps.
(Above) Original advertising sign for the E-Z ride seat; patent April 26, 1898.

seems mired in error, as de Sivrac apparently never rode anything with two wheels, and his patent, obtained in France, was for a horse-drawn carriage.

By the end of the century, the French did see something of a fad emerge, based on the popularity of hobbyhorses, and the fad quickly spread to England. *Celeripedes*, as they were called, had wooden bodies of animals, usually horses and lions, and a gentleman would straddle the beam between the wheels and stride along as fast as his legs could take him. Dandies showed off in city squares, riding the curious vehicles. The public was greatly amused, but because of the lack of steering, celeripedes did not capture much more than the imagination

In 1804, an American inventor by the name of Bolton was granted a patent for a four-wheeled, manually operated vehicle that represented a move toward sophisticated gearing, later used in bicycles.

But Bolton's vehicle was significantly cumbersome and exhausting to use. To actuate the gears, one operator had to pump a handle which set in motion a train of gears, while a steersman sat up front. Bolton's machine never caught on, and for the most part, four-wheeled over-the-road vehicles had seen their day. But because they were forerunners to the pedaling and gearing systems adopted by latter day bicycle designers, they were noteworthy inventions in the evolution of the bicycle.

In fact, the first bicycle was known to have been built until 1816. A German agricultural engineer and inventor by the name of Baron von Drais de Sauerbrun had been experimenting with horseless carriages and two-men driven vehicles, but decided these machines were too complicated, too heavy and too impractical to pursue. Instead, he returned to the wheeled hobbyhorse, eliminating the gimmicky animal heads and bodies in favor of a front wheel that could be steered. A length of wood called the "backbone" provided the shape of von Drais'

contraption, and two small carriage wheels in tandem, complete with a saddle and back rest added to its practicality and function. The rider would straddle the vehicle and propel it in much the same way as the hobbyhorse. On flat land and downhill, he'd be able to glide along, expending roughly half the energy as walking but covering much more distance. Going up hills presented a problem, and most riders would have simply dismounted and pushed the "Draisine" or "Swiftwalker" to the top of the hill.

Von Drais had originally intended for his invention to be called a Laufsmachine, which means "running machine" but "Draisine" caught on instead and von Drais relented. Other names for von Drais' invention include Draisienne, hobbyhorse, walkalong and the English imitation, pedestrian curricle. Riders of the Draisines were called runners, veloci-pedestrians and velocipedists.

In 1817, von Drais rode his Draisine from Mannheim to Schwetzinger, a journey which took four hours by post wagons, in one hour. Soon after,

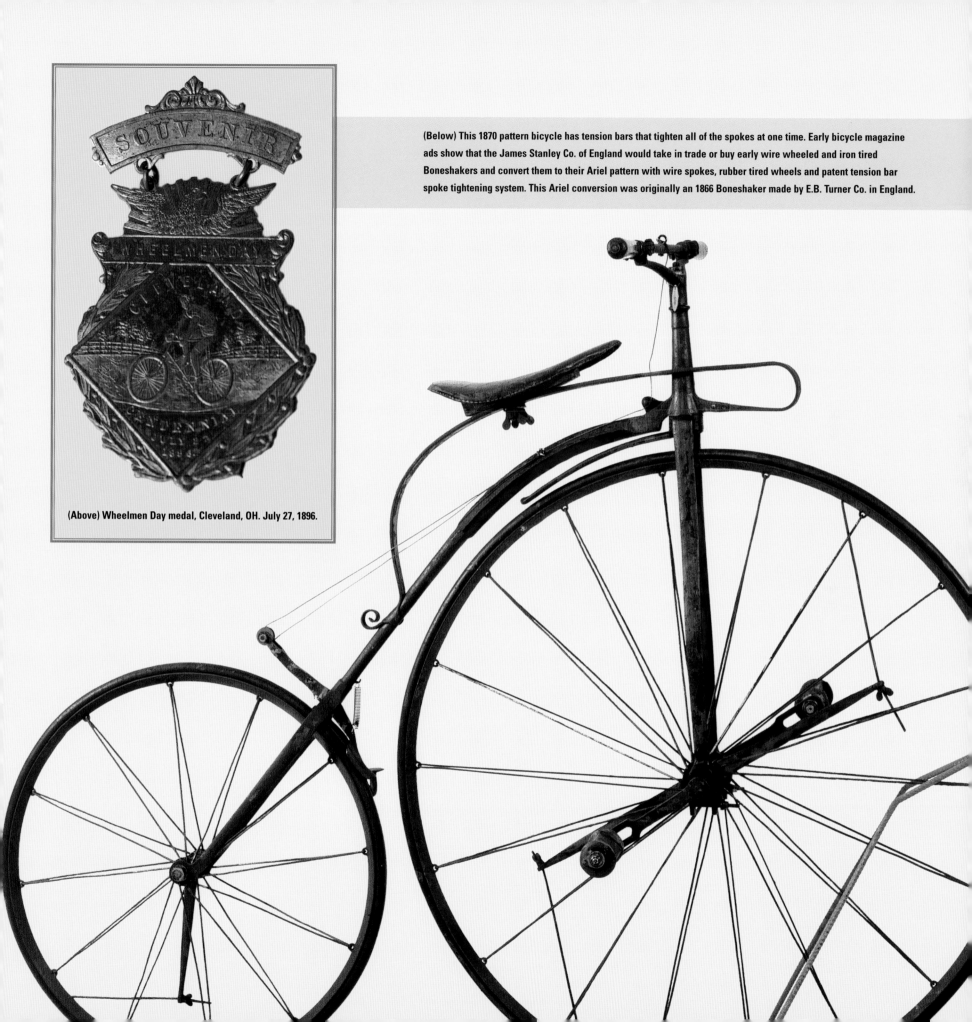

(Below) This 1870 pattern bicycle has tension bars that tighten all of the spokes at one time. Early bicycle magazine ads show that the James Stanley Co. of England would take in trade or buy early wire wheeled and iron tired Boneshakers and convert them to their Ariel pattern with wire spokes, rubber tired wheels and patent tension bar spoke tightening system. This Ariel conversion was originally an 1866 Boneshaker made by E.B. Turner Co. in England.

(Above) Wheelmen Day medal, Cleveland, OH. July 27, 1896.

he began to manufacture Draisines, continually making improvements, such as a padded, adjustable seat, a cord-operated brake and a prop stand. Eventually, he even added an odometer. By the end of 1818, Draisines had become a fad amongst the rich, aristocratic societies of Europe. The country roads of England were soon filled with dandy horses, as young Regency bucks straddled atop the latest invention. Just two years later, Draisines came into use among professionals, such as doctors, postmen and clergymen.

While the speed of Draisines was a strong selling point, the lack of good roads presented a problem for earliest documented bicycle race, going about six miles from Munich to Nymphenburg Castle and back, with a man named Semmler winning the race.

But the writing was on the wall for Baron von Drais and the Draisine. The early nineteenth century patent laws were virtually non-enforceable, and his machine was basically copied throughout Europe. Because of this, von Drais was unable to financially capitalize on his invention, but his Draisine will always be considered by most historians as the great-grandfather of the bicycle.

One of the men who copied von Drais' design was Dennis Johnson, a coachmaker from London

"Progress should have stopped when man invented the bicycle."

Elizabeth West

riders as well as von Drais. In the coming decades, both issues would be addressed and improved upon. In 1819, twenty-six swiftwalkers competed in the who made a few improvements on the Draisine. Johnson added an adjustable saddle as well as an armrest, which he felt helped to reduce the amount of

strain on the arms when riding. Johnson's version of the Draisine was more upright than von Drais' and despite the fact that he was probably inspired to design his own dandy horse after seeing or hearing about the Draisine, historians are quick to point out that Johnson's improvements certainly helped popularize the vehicles.

By 1821, the hobbyhorse was on its last legs, so to speak. Louis Gompertz, an English inventor, designed a hobbyhorse with an auxiliary hand gear over the front wheel—an effort to create continuous drive by supplementing the power provided by the stride. The device made steering the hobbyhorse more difficult, but it did increase the speed to about twelve miles per hour, slightly faster than its predecessors. However, the more complicated design did not appeal to riders much. Hobbyhorses, Draisines, walk-alongs, or swiftwalkers had evolved about as much as anyone cared for. A new velocipede was needed—one that would incorporate new technology and enable man to reach higher speeds with

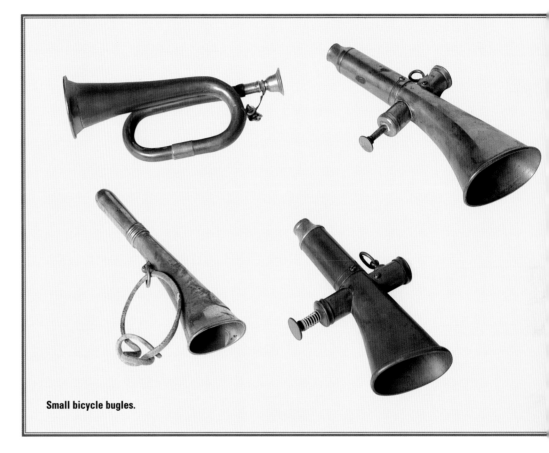

Small bicycle bugles.

less exertion. Over the next forty years, in the period between 1821 and 1865, the world would bare witness to remarkable technological advances in many areas of industry and invention. In turn, the continually evolving development of the bicycle would undergo some very strange, surprising and revolutionary advancements, forever changing transportation and the world.

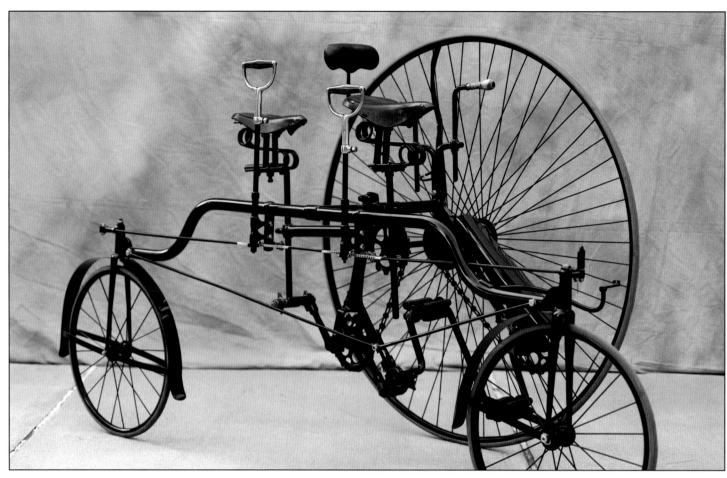

Velocipedes and Boneshakers

The dandy-horse fad may have come and gone by 1821 or so, leading many critics and satirists at the time to dismiss man-powered vehicles as gimmicks, never to replace the horse. The next 50 years may even have borne these skeptics out to some degree, as no new improved dandy-horses or contraptions caught the public's attention in any significant manner. However, there were some note-worthy developments that quietly brought the world closer to a bicycle. By 1830, the French government believed the improvements to the Draisine were so extraordinary that they purchased some for postmen in more rural parts of the country.

In 1836, a blacksmith from Pierpont, Scotland named Kirkpatrick McMillan came up with a vehicle featuring a rear wheel that was rotated by levers and a crank system. With swinging pedals, the rider was, for the first time, able to lift his feet off the ground and still propel himself. McMillan first experimented with a tricycle, but he felt that it was too laborious and difficult to steer. In 1838, he found a way to employ his system on a bicycle, and he ultimately became the first man to build a Draisine vehicle that could be propelled with both feet off the ground.

Another of McMillan's contributions was the upturned handlebars, still in use today. But it was the Scotsman's contribution of a pedal system that truly

moved the bicycle from the dandy stage to the practical. McMillan succeeded in placing the cranks to the rear axle by attaching connector rods to pedals suspended under the handlebars. The result was a bicycle that was still difficult to maneuver, but it finally enabled riders of the Draisine to propel themselves without basically "running" the bike with their legs and feet.

McMillan proved that he could make such a vehicle, but it is not known whether he actually produced more than a few for himself. He did, however, make quite a name for himself riding about the streets of Edinburgh, puzzling the local bobbies and knocking down women and little girls, leading to several arrests! He was also known to race stagecoaches and perform trick riding skills, such as

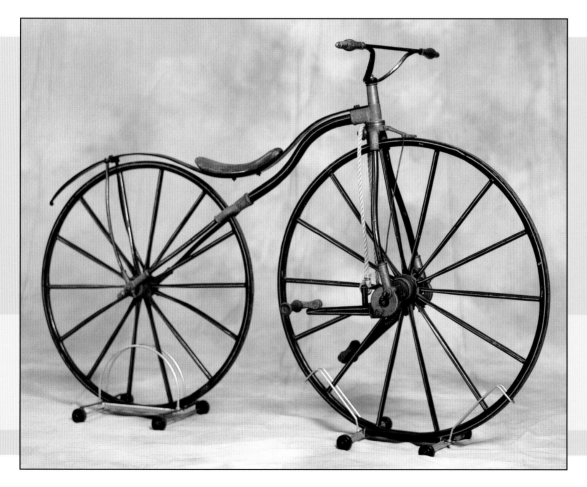

"The bicycle is the most civilized conveyance known to man. Other forms of transport grow daily more nightmarish. Only the bicycle remains pure in heart."

Iris Murdoch

1869 Velocipede was one of the very first Velocipedes to experiment with a pawl and ratchet drive at the front wheel. The two pedal cranks work in an up and down action, which activates the pawl and ratchet mechanism on each side of the wheel. A rope going through a pulley at the top of the frame connects the two cranks. Pressure on one crank raises the opposite crank. A small brake pad near the front hub activates a brake spoon at the front wheel.

holding little girls in one arm while steering with the other, much to the amusement (and perhaps dread!) of local townspeople.

By 1845, another Scot, Gavin Dalzell, a Lesmahagow cooper, decided to make what he felt were improvements on McMillan's machine. He was able to design the Draisine so that the pedals were right below the saddle—close to the placement of pedals on bicycles that we have today. Dalzell also used a drop frame and he increased the slope of McMillan's front forks. With handlebars and mudguards nearly identical to modern day bicycles more than a hundred years later, Dalzell's vehicle became known as the "wooden horse."

The interesting thing about the designs of McMillan and Dalzell is that they were practical and operational vehicles of self-propulsion, yet they never captured much of the public's attention. In fact, decades would pass before the design of velocipedes returned to the place where McMillan and Dalzell left off. Had McMillan continued to improve his design, perhaps leading to the bicycle, the world may never have seen the coming "boneshakers" and "ordinaries" that would thrill riders and collectors for decades to come.

In that strange void between McMillan and Dalzell's vehicles of the 1840s and the end of the century, when inventors and designers would return to those designs, there was a little-known carpenter by the name of Willard Sawyer who continued to pursue the development of four-wheel velocipedes. Sawyer was not interested in the hobbyhorse; rather, he set about using his carpenter's skills to build high-quality, carriage-like velocipedes, and ultimately invented new and improved methods of motion. He successfully built, marketed and sold his hand-propelled velocipedes, sometimes called "double-action, self-locomotives" and included royalty and aristocrats among his customers.

By 1858, Sawyer's velocipedes were known for their superb craftsmanship which he sold worldwide to the Prince of Wales, the Crown Prince of Hanover

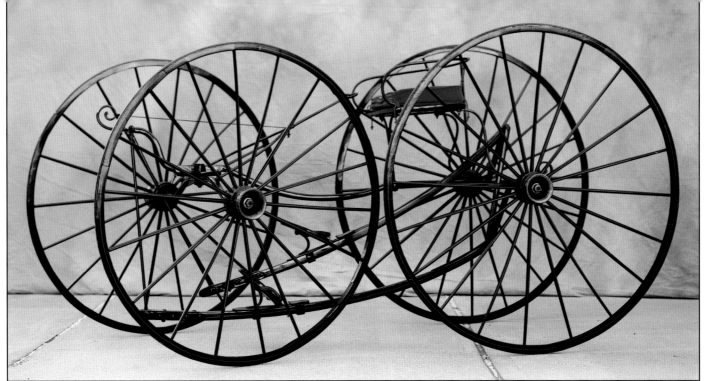

The 1851 Sawyer Quadricycle has 42-inch rear drive wheels and 39-inch front steering wheels. Two foot levers are connected to the offset rear axle. Activating the foot levers propels the cycle while the front tiller handle controls the steering.

and royalty in India, Australia and the United States. His velocipedes were light and durable, despite a wrought-iron crankshaft, large throw and four bearings. Most significantly, the crankshaft was built from a single length of iron, a remarkable achievement at the time. One of his models, the "Sociable" was built to carry up to six persons, which he marketed for "excursionists" who were required to propel the vehicle. He had other models as well, including the "Promenade," the "Visiting Carriage," the "Racer," and the "Lady's Carriage." Tourists and travelers were also drawn to Sawyer's velocipedes, sometimes traveling over 70 miles in a day. To those who championed the velocipedes at the time, only the condition of the roads prevented them from covering more ground in more comfort.

While Sawyer's machines were safe and durable, they were not built for speed—a quality that would attract riders in the not-too-distant future. In addition, the expense Sawyer's velocipedes prohibited all but the wealthy from owning one. Yet the craftsmanship and comfort of these self-propelled vehicles created a dedicated following of riders who were drawn to Sawyer's catalogs and couldn't wait to try the latest advertised model bicycles.

Around the mid-1860s, heavy old four-wheeled, self-propelled vehicles were mounting a desperate, last-ditch effort to capture the public's imagination,

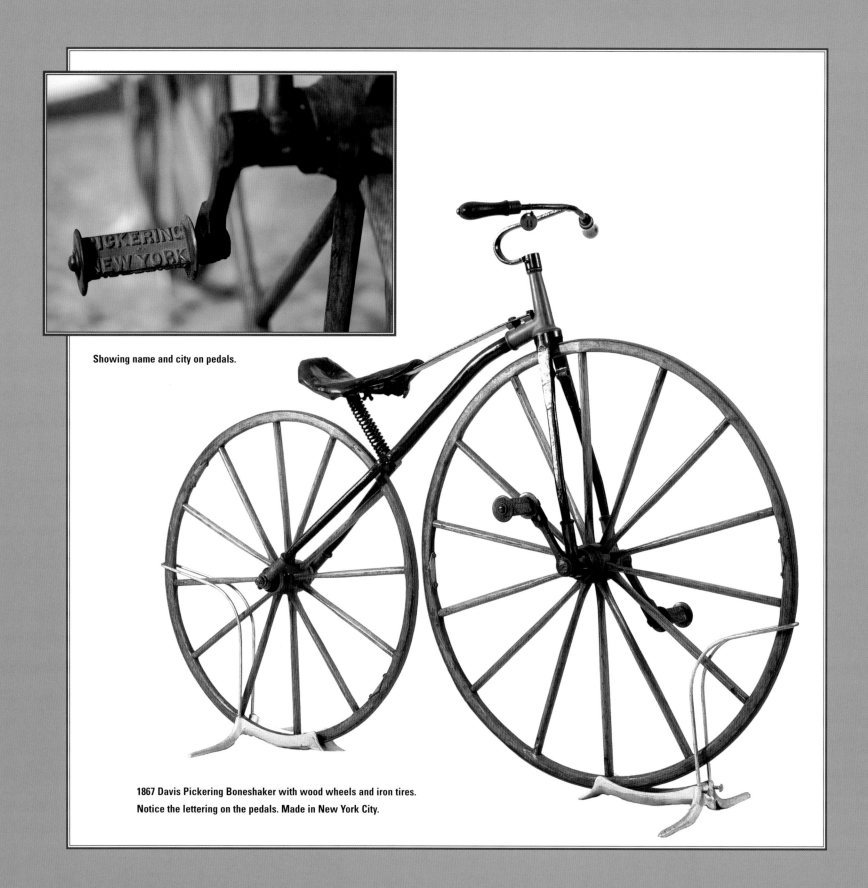

Showing name and city on pedals.

1867 Davis Pickering Boneshaker with wood wheels and iron tires.
Notice the lettering on the pedals. Made in New York City.

to little avail. Artistic sketches, renditions and illustrations document the unique as well as the ridiculous contraptions that could be seen speeding through the a constant upright position, cause chaffing between the thighs, and saddle seats would ultimately prove most uncomfortable for any extended period of time.

> *"There is nothing, absolutely nothing, quite so worthwhile as simply messing about on bicycles."*
>
> *Tom Kunich*

countrysides of Europe. One such contraption was the Celeremane—a four-wheeled carriage which was propelled by the rowing efforts of four men, (two facing backwards) and a coxswain. It was soon discovered that legs would ultimately prove stronger, and most inventors and designers did not pursue arm-propelled vehicles beyond experimentation.

Other riders who lamented the cost of four-wheeled velocipedes were also quick to point out that on long journeys, the money saved riding one as opposed to the cost of riding in a horse-drawn carriage—sometimes up to 15 shillings a day—made the vehicle a worthy investment. There was also initial concern that two-wheeled vehicles would require

Most significantly, however, inventors and manufacturers of four-wheeled velocipedes spent the middle part of the nineteenth century innovating new designs and attempting to solve the mechanical and physical problems that had plagued the inventors of Draisines and hobbyhorses. Mass production methods were transforming the transportation industry. Steam-powered ships were traveling rivers around the world and railways were growing and expanding so rapidly that the stagecoach all but disappeared from the landscape. Still, the railways were expensive, and socially, the call for man to produce a cheaper method of travel is what eventually proved the greatest motivation.

It is pretty clear that the bicycle was never invented but developed gradually over time, with inventors and mechanics simply picking up where others left off before them. And so it was that after designers of four-wheeled velocipedes put a great deal of their efforts into pedals and crankshafts and other methods of self-propulsion, it was the hobbyhorse that would eventually make a comeback, taking advantage of the progress in vehicular design. In 1861, Pierre Michaux and his son Ernest, makers of perambulators in Paris, France, experimented with a hobbyhorse that was driven by pedals attached directly to the front-wheel spindle. They called their vehicle a "Velocipede," and it was made with an iron frame, iron wheels with wooden spokes, a vertical front fork, handlebars for steering and a brake

The 1867 Velocipede has a 36-inch front wheel and a 32-inch rear wheel. It includes a rear wheel brake and coasting pegs. Made by William Sargent Co.

attached to a cord. A saddle was attached to the wooden frame with a steel spring; however, this spring was virtually useless in absorbing much shock—leading to the popular name of *boneshaker*. Some historians believe that the Michaux father and son team did not actually invent this velocipede; rather, it was the work of one Pierre Lallement, who took out the patents and later sold them to the Michaux. Lallement was a coach maker who worked for Michaux, and a bitter fight for recognition and market share would ultimately sour their relationship and turn them into competitors. Unfortunately for Lallement, he seemed to just miss the waves of fortune he sought so desperately to ride. He left France in 1863, hoping to get a jumpstart on Michaux by moving to Connecticut and manufacturing velocipedes in America. He and an American by the name of James Carroll applied for and received the first American bicycle patent, but the velocipede craze had not yet caught on in the United States. Meanwhile in France, Michaux was

enjoying great success with his company, Michaux et Compagnie, in Paris. Had he remained in America a little longer, Lallement may well have surpassed his rival, but fearing he was missing out on an opportunity, Lallement returned to Paris in the hopes of competing with his old employer. However, the 1860s proved to be a spectacularly successful decade for Michaux, as his high-quality velocipedes were in great demand. Michaux employed over 300 workers who produced five velocipedes a day, and gave free riding lessons to anyone who could afford one. "Velocipedomania" had become all the rage in both France and England.

Demand was so great by the end of the 1860s, that even Michaux could not keep up. He sold his stake in his company to Compagnie Parisienne, which continued to manufacture velocipedes as late as 1891. The streets of Paris were full of boneshakers, popular not just with the wealthy, but with athletes, gymnasts, the young and the old. But it wasn't long before Parisian whimsy became a nuisance,

as pedestrians were often overrun by aggressive riders. Much of the public sentiment seemed to revolve around the notion that velocipedes would

THE CONVERTED "ARIEL" BICYCLE.
" And on *this*."—*Hamlet*,

TRIAL BEFORE PURCHASE.

This is practically ensured by the following conditions: The full price paid for wheels or Bicycles will be returned if they are not approved after trial, and are sent back, carriage paid, within 7 days of delivery. Machines and wheels must be tried on boards only, or upon a clean dry road, and must be returned wholly uninjured, or the cost of restoring will be deducted. We cannot undertake to guarantee the Bicycles, as we cannot ensure their being fairly used, but they will be found capable of rougher usage without injury than any other make.

PAINTING :—Machines can be painted to order, without extra charge, in any required colours, at a week's notice.

One of the Starley Company's ads, explaining the conversion process. Old Boneshakers, such as this one made by E. B. Turner and Co. of England, found a second life when converted to the Starley Pattern.

prove to be another fad that would run its course in due time. But that was not to be. The craze proliferated across all class lines, as aristocrats and the working class both took an enthusiastic liking to this new mode of transportation.

Racing was, of course, tremendously popular amongst the velocipede set. The first recorded race took place on a track in 1868 at Saint Cloud outside Paris, covering a distance of nearly a mile. James Moore, a British friend of Ernest Michaux, won the race. The following year saw the first road race take place between Paris and Rouen, a distance of about 80 miles. This time, all different makes and designs took part, with over 300 riders eager to compete. Monocycles, bicycles, tricycles and even quadricycles were entered, but it was James Moore once again who bested the field on his velocipede. In fact, most of the best times were turned in by riders aboard their two-wheeled velocipedes, which further cemented its reputation as the superior self-propelled vehicle of the time.

By 1869, however, velocipedes were about to virtually disappear from the Parisian landscape. The Franco-Prussian War of 1870 had a paralyzing effect on the industry, as factories began to produce weapons instead and the economy left little room for recreation in the French lifestyle. British and American velocipede manufacturers picked up the slack, but Pierre Michaux did not fare well. After selling his stake in Compagnie Parisienne to Olivier Freres, Michaux regretted putting himself into early retirement and made a feeble attempt to strike out in business again under his own name. Freres claimed this was a breach of contract and successfully sued Michaux for 100,000 francs. The judgment ruined Michaux, who died penniless in a mental hospital in 1883.

The Franco-Prussian War also gave designers and inventors some time to reflect on the shortcomings of boneshakers. Most notably, the wooden bodies and wheels were cumbersome and prone to destruction during ordinary usage. Despite their popularity in

Two Norman Rockwell figurines.

considered "bicycles." An English company by the name of Reynolds and May unveiled its "Phantom" model in London, and the difference between the boneshakers of just a few years before was immediately apparent. On boneshakers, the front wheel would, when turning, rub up against a rider's legs, requiring him to wear leather boots to prevent damage to clothing and skin. The Phantom found a way around this problem by making the framework pivot in the center, leaving the saddle and the pedals in line. The Phantom also had the first metal-spoked suspension system and solid rubber tires. Though these improvements would ultimately be common in later models, the Phantom suffered erratic steering problems and did not capture the public's attention. But it was an important breakthrough—one that would ultimately lead to a craze that reached proportions well beyond that of a fad. The design of the Ordinary was the beginning of the bicycle.

America and England, boneshakers were rarely seen in France anymore, and inventors were beginning to address these problem areas with a newfound enthusiasm.

Most of the improvements over boneshakers revolved around the design of the wheels. High-wheelers or "Ordinaries" were the first machines

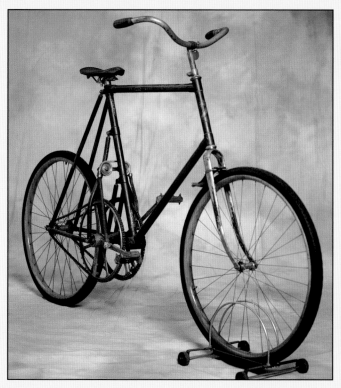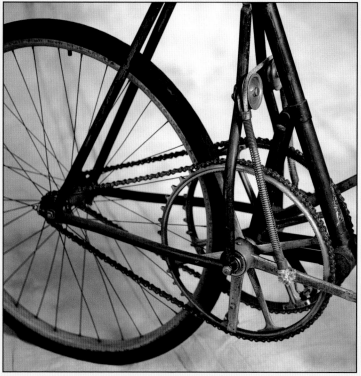

The Latimer Pneumatic Tire Safety Bicycle

This tall frame bicycle has a complicated drive mechanism, with two 14-inch sprockets, one on each side of the frame. Each sprocket

has regular 1-inch pitch teeth on the outer perimeter. It also has hundreds of very fine teeth on the inner rim of the sprocket. There is a

long arm pedal crank on each side of the frame that operates in an up and down motion. A rope going through a pulley at the upper part

of the frame connects them to each other. As you push down on one crank, it raises the opposite crank. A small sharp spring-loaded

pawl is attached to each pedal arm and at a certain point, as you push down on the pedal crank, the pawl engages the fine teeth on the

inner rim of the large sprocket. A regular 1-inch pitch chain on each side connects the large sprocket to a small rear-wheel sprocket

on each side of the rear wheel and propels the bicycle forward. The Latimer Pneumatic is considered a transitional bicycle. Patented

August 10, 1897.

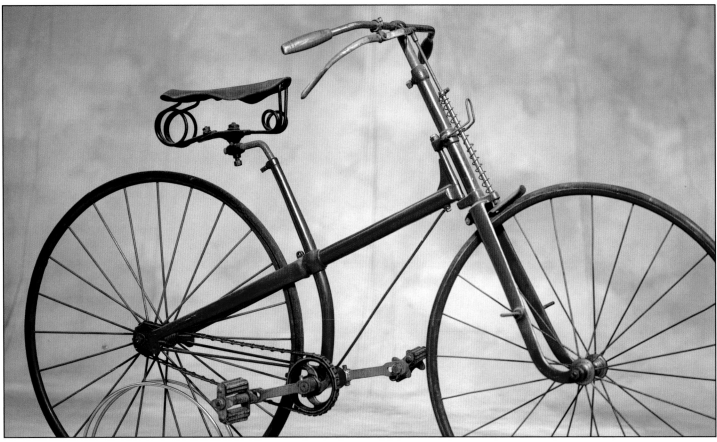

The Ordinaries and Safeties

The appearance of the Phantom in 1870 signified the beginning of a new era in velocipede design, despite the fact that the Phantom itself was not successful. The fore and aft steering, though unique, made it difficult to manage. But inventors and designers were smitten and newly inspired. Rubber pedals soon replaced metal ones in 1871, and the pedal's new design represented a significant departure from pedals in the past. These pedals encouraged the rider to use the ball of his feet on contact, allowing for a better, less constrictive range of motion at the ankle. Steel rims were also becoming common, but it was the increase in size of the front wheel along with the reduction in size of the rear wheel that defined the ordinary.

Ordinaries developed very logically, even though people are as puzzled by them now as they were in the nineteenth century. In 1872, Smith & Starley, a company in England, unveiled the Ariel, considered by most historians to be the first real bicycle. The Ariel looked very much like a high-wheeled Ordinary, with its large front wheel and its tiny front wheel. It also had long arms with footrests specifically designed for the rider to rest his legs when coasting.

Because chain technology had not been fully developed as of yet, designers concluded that the best way to increase the speed of velocipedes was to

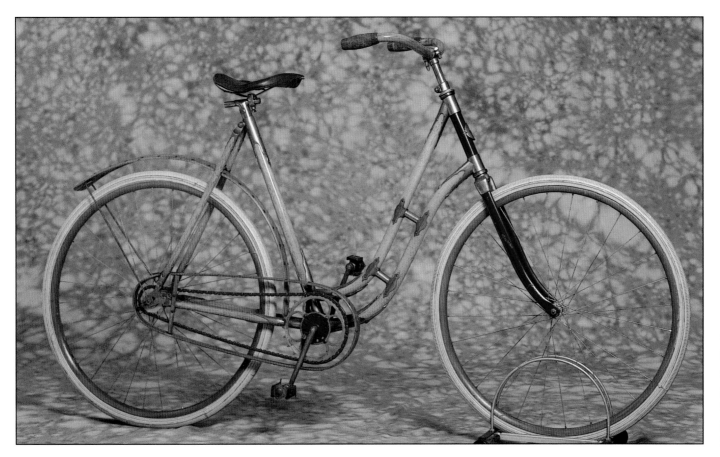

1898 Lady's Chillion wood frame bicycle complete with wood fenders, chain guard and handlebars. Metal reinforcement at all stress points. Made by M.D. Stebbins Mfg. Co., Springfield, MA.

simply increase the size of the front wheel—the principle being that each turn of the pedal enabled the wheel to travel over more ground. In time, it was not uncommon to see Ordinaries speeding across roads with front wheels as high as 60 inches or more with rear wheels just 17 inches or so. Though some Ordinaries had front wheels that reached an incredible 100 inches.

Needless to say, mounting the Ordinary was something that had to be practiced and ultimately mastered before one could venture out into the countryside. A rider would usually put his left foot on a step, keeping his hands on the handlebars and his right foot on the ground. Then he would begin pushing off with his right foot, getting the Ordinary in motion. Once a sufficient speed was attained, he

would shift his weight to the left foot and scoot off the step, into the saddle and begin peddling. It sounded easy and it looked easy when done by others, but cyclists would soon learn that mounting was usually the most difficult part of riding.

By 1875, the Ordinary had become a very practical bicycle, operated by travelers, racers and most importantly, the average person with a desire to go from point A to point B. City dwellers would have found it extraordinarily expensive to own a horse, so getting away from town was expensive and time-consuming. However, weekends were now filled with

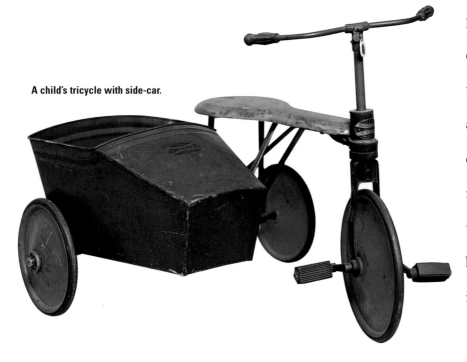

A child's tricycle with side-car.

urbanites riding Ordinaries that filled the country roads of England and France. Riders took advantage of stage coach roads, which were not usually the most rider-friendly roads for bicycles—usually sandy gravel or chalk. In less than desirable or rainy weather, the roads became quite slippery to manage, and the wheels often became clogged with grit and mud. Hitting even a small stone could lead to "headers" or "croppers," which were hard falls straight over the handlebars, due to the balance and design of the large wheels on Ordinaries. Spoon brakes, which were small metal shoes on the ends of push-rods, were of little value to a rider after a dangerous bump or hole in the road. Newspapers of the time printed ghastly accounts of fatal bicycle accidents due to these headers, yet cyclists were not deterred much. The fact that they were no longer riding on boneshakers really inspired Ordinary riders to be adventurous and independent. The quality of a bicycle ride was improving, and cyclists began to insist that the quality of their roads keep pace.

It was estimated that by 1878, 50,000 Ordinaries were in use in England alone. By 1878, Americans began to see for themselves what Europeans had gotten themselves all in a tizzy about. Albert Pope, a Civil War veteran from Boston founded the Pope Manufacturing Company in Hartford, Connecticut, where he imported bicycles into the United States and set up a riding school. Then, in a moment of sheer brilliance, Pope commissioned a mechanic by the name of Atwell to make use of British designs and build bicycles in the United States. Atwell came up with a suitable cycle which cost over $300 and is considered the first bicycle made in America. Pope therefore, became the father of the bicycle industry. He immediately set to work with plans to manufacture the "Columbia" Light Roadster, a contract he entered into with the Weed Sewing Machine Company, and some historians consider that Ordinary the one that launched the cycling craze in America.

Velocipede inventors quickly moved to the courts in an attempt to preserve their marked share, but

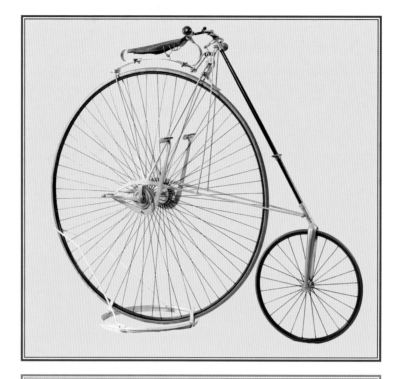

The 1885 Special Star has a 50-inch rear drive wheel. The two foot levers operate in an up and down motion and are attached by leather straps to the rear ratcheted drive hub mechanism. Made by H.B. Smith Cycle Co. of Smithville, NJ.

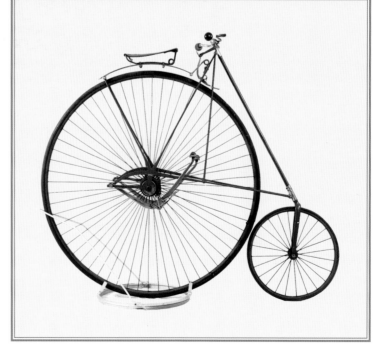

The 1886 Star with a 48-inch rear drive wheel includes a quick-change gear made by H.B. Smith Cycle, Co. of Smithville, NJ.

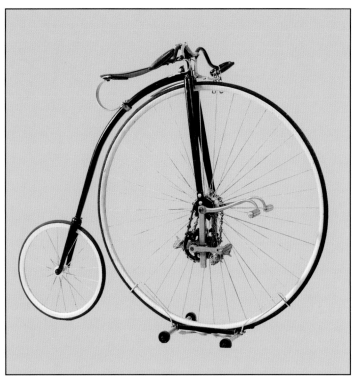

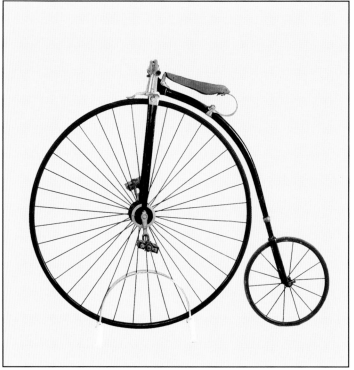

(Above left)

An 1885 Rudge Chain Drive is a highwheel cycle that can accommodate taller riders. The pedal cranks are attached to extension and can be raised or lowered according to the height for the rider. Chain links can also be added or taken off as needed. Made in England by Rudge Cycle Co.

(Above right)

The 1887 36-inch Junior Size Highwheel Bicycle is equipped with a front wheel brake.

(Right)

An 1886 38-inch American Ideal Made by Gormully & Jeffrey of Chicago, IL.

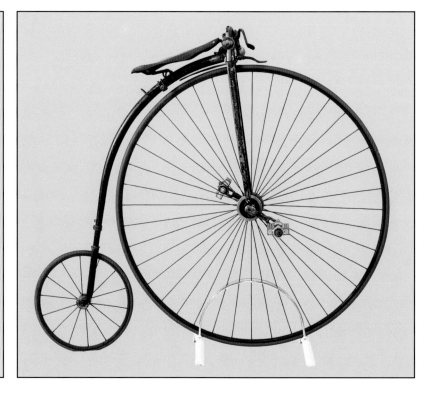

Pope mounted a sophisticated challenge and defeated them, paving the way for mass production of Ordinaries. More and more, bicycles were becoming commonplace in both the U.S. and Europe. Some segments of society, as well as local municipalities attempted to keep bicycles off certain roads or off roads during certain hours, since they did present some problems for the citizenry, such as collisions. Horses were also afraid of the noiseless bicycles, which seemed to creep up and startle them, causing them to rear back or gallop off unexpectedly. Something of a war between horse owners and cycling enthusiasts emerged.

Before long, cyclists found themselves in a battle over who had rights to the nation's roads. Pope mounted a campaign in the courts, arguing over a bicyclist's right to ride on public roadways. He promoted cycling as a means to health and happiness, and trumpeted the bicycle as a major quality-of-life improvement for humanity, despite the fact that many physicians at the time were highly concerned that high-wheeled Ordinaries were actually a hazard to one's health! Again, in a marketing move ahead of his time, Pope offered prizes to doctors who published the most persuasive articles stressing the benefits of bicycle riding.

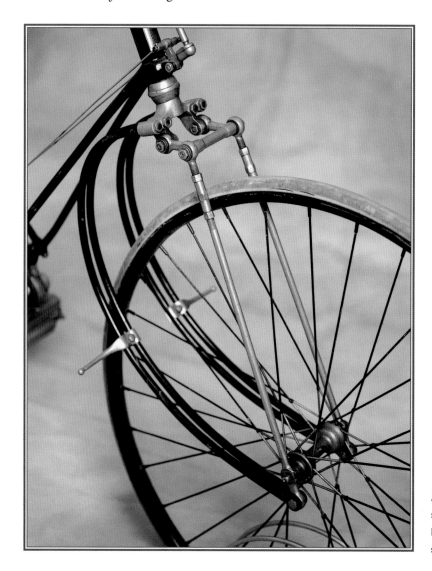

An 1888 Victor spring fork hard-tire safety bike.

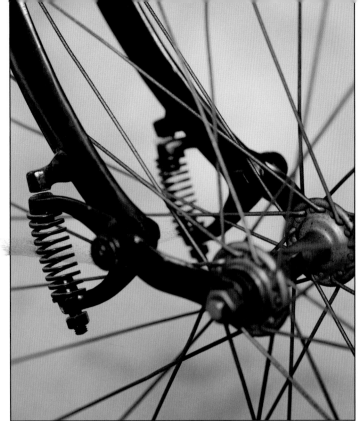

(Top) Detail of spring action front fork.

(Bottom) 1889 Columbia Light Roadster is equipped with many deluxe features including a spring action front fork.

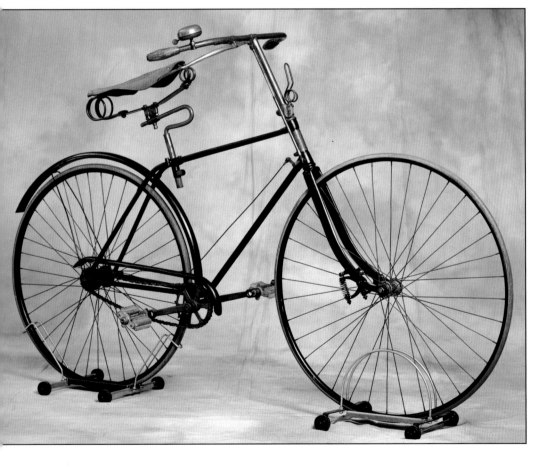

Beyond his attempts to influence American public opinion of bicycles, Pope was instrumental in the foundation of early bicycle clubs, which proliferated across the country. More and more people were turning to the bicycle, not only as a means of transportation and recreation, but also for the social aspects these clubs had to offer. By the late 1870s, the upper-classes were less involved in the novelty of bicycling. It was the middle class—the tradesman, doctors, teachers and civil servants—who took to bicycling because riding was becoming more and more practical and affordable. People were able to get to work in less time, so movement out of cities and into suburbs became a more realistic option.

Although the Ordinary was considered a very successful design, inventors and designers continued to experiment with perceived shortcomings of the bicycle. Mounting, steering and pedaling were still areas that could be improved, many felt, and manufacturers put a lot of their energy into research and development. For starters, they addressed the front

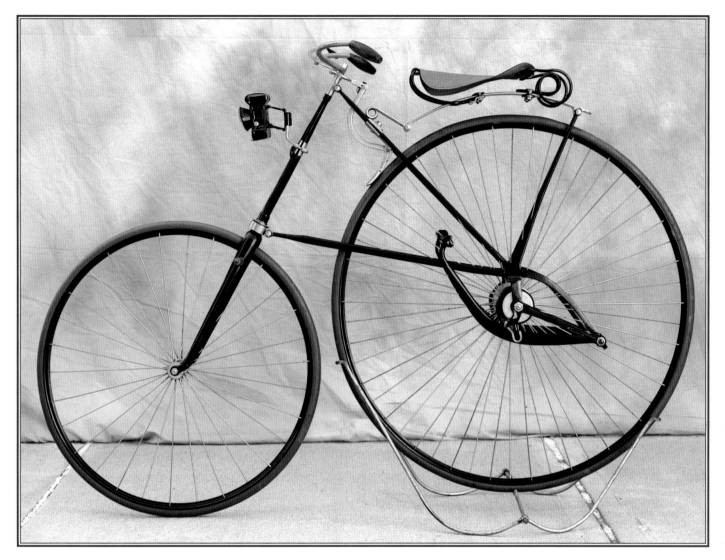

An 1892 Rover Star made by H.B. Smith Cycle, Co. of Smithville, NJ. Two foot levers connected by leather straps to rear wheel drive mechanism propels the bicycle forward.

wheel, attempting to somehow make it lighter. The move to rubber tires certainly helped, but it wasn't until James Starley of Starley & Smith in Coventry produced the Tangent system. The Tangent was a wheel that obtained its stability by the spokes tensioned in four different directions. So innovative and sound was the Tangent system, that it remains today the strongest method of building a bicycle wheel.

Still, hollow wheel rims and new spoke systems were not what ultimately led to the Ordinary's

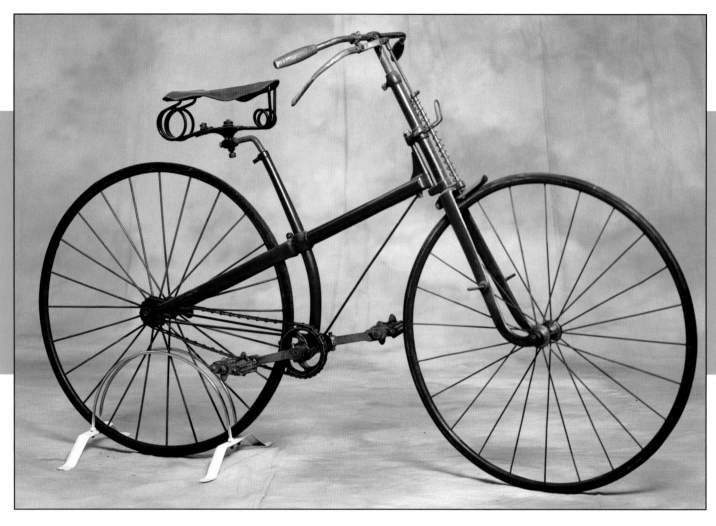

An 1879 junior size hard-tire safety bicycle.

extinction. Other designs began to appear on the market, but the Ordinary rider resisted, believing tricycles and "Safety" bicycles to be designed for old men, women and sissies. When Safeties began to out-perform and out-race Ordinaries, the writing was on the wall. The Ordinary was barely 10 years old when it was replaced in quick measure by the Safety,

and the craze the Ordinary inspired and bore witness to paled in comparison of what was soon to come.

By the end of the 1870s, bicycle designers sought to eliminate the danger of the high-front-wheel/low-rear-wheel designs, but the task was not as simple as it seemed. Ordinary riders enjoyed the height of their ride, as well as the fact that they were positioned high

atop the wheel, instead of pushing a wheel in front as one would with a wheelbarrow. It was also fair to say that most riders of Ordinary bicycles were, in general, young and athletic, for they had to be to survive a fall from atop the high wheels of the times! However, the sensibility of safer models, such as the "Facile," the "Dutton" and the "Devon" inevitably brought thousands and thousands of people who would not normally be drawn to cycling, out onto the roads on bicycles that did not threaten them so severely with "headers," resulting in broken bones or worse.

In 1884, Starley made the "Rover" out of his Coventry Machinists Company in England. The Rover, though clearly not the sleekest, most beautiful bicycle ever invented, initiated what would inevitably become the bicycle revolution. Bicycle manufacturers who had been fighting in court for much of the 1870s and early 1880s over patent violations quickly discovered that their energies would be better spent by making bicycles that could compete with the early Safeties, as that bicycle was about to render all their civil cases moot. This new bicycle, which made its way from England to America, was about to obliterate the competition.

One of the earlier Safeties was "The Kangaroo," a pony high wheel, which was actually more like a geared, low-wheel Ordinary, featuring a double chain drive and a front sprocket that attached to the front forks. Within a year of its debut, nearly every English bicycle manufacturer was producing their own version of one. The reasons for the Kangaroo's popularity were the chain drive, which allowed a rider to gear up, and the size of the Safety itself. The Safety had two wheels

"*I thought of that while riding my bike.*"

Albert Einstein, on the theory of relativity

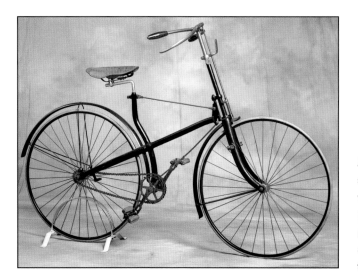

An 1889 hard-tire safety bicycle complete with front wheel brake, light bracket, coasting pegs, mounting step and removable top bar to convert to a girl's bike.

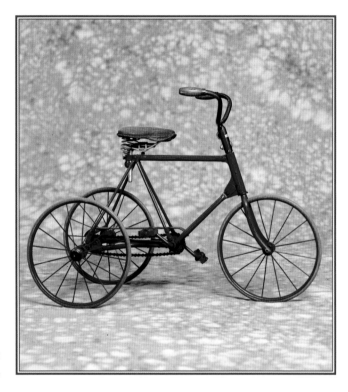

Child's chain drive tricycle.

of similar size, but most importantly, it featured a loop chain that ran over a pedal-driven socket, and the gears located on the rear axle. It enabled the rider to multiply his output of energy to the rear wheel through a new, innovative gearing system. The saddle sat over the center of the frame, and the steering mechanism attached to the fork over the front wheel. This sloped front fork increased stability as well, and pivot points dispersed around the bicycle created a smoother ride than any high wheeler ever could.

Safeties not only brought the rider closer to the ground, but they also eliminated for the most part, the possibility of him flying over the handlebars after hitting small bumps or indentations in the road. Manufacturers were beginning to use springs to absorb shock, both in the seat posts and the front and rear forks, since road conditions were not keeping pace with the improvements in bicycle designs. That was until an Irish veterinarian by the name of John Boyd Dunlop was attempting to fix his son's bicycle in 1889 by fitting a piece of rubber hose around the rim and filling it with compressed air. The result was the pneumatic tire, and just four years later, it was impossible to find a new bicycle with a solid rubber tire anymore. The fat pneumatic tire may have amused those who first laid eyes on them, but their ability to increase both speed and comfort could not be denied. Dunlop became a millionaire, and a social revolution was underway. Millions of people world-wide were willing to ride bicycles by the early 1890s, as they became more comfortable and less dangerous.

In essence, bicycling had arrived and was open to everyone who wanted to ride.

Naturally, bicycles became big business and were mass-produced on assembly lines to meet worldwide demand. They became so pervasive that people quickly dropped any reservations they may have had about bicycles or the cyclists themselves and simply hopped on one and began pedaling. Young and old alike were hooked, and the mid-1890s saw a bicycle craze unlike anything before. Every cycling record was broken by a pneumatic Safety, a clear demonstration of the superiority of these new machines.

In 1885, Starley's company came up with another feature on his bicycle that would prove so revolutionary, it is still used today. The diamond frame was another design first used on a revised Rover and manufacturers everywhere began to implement it on many Safeties. When seats, handlebars and pedals needed adjustment, they were easily accomplished with the diamond frame. However, the significant advantage of the diamond frame was that designers

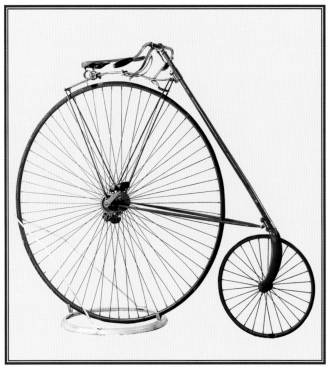

The 1887 Eagle has a 50-inch rear wheel. In order to mount the Eagle, you take several running steps and when the pedal is at the lowest point, you step on the pedal and ride it up into the saddle. Made by Eagle Manufacturing Co. of Torrington, CT.

could now lower the crossbar without compromising the strength of the bicycle. This brought women into bicycling at a staggering flow. Before, women who wanted to cycle in their traditional clothing had a difficult time of it. Now, the drop frames on Safeties played a major role in the bicycle boom of the late nineteenth century. Women became customers! Not only were women able to participate in the bicycle revolution, but their interest in cycling clearly helped usher in the social liberation they desired as well.

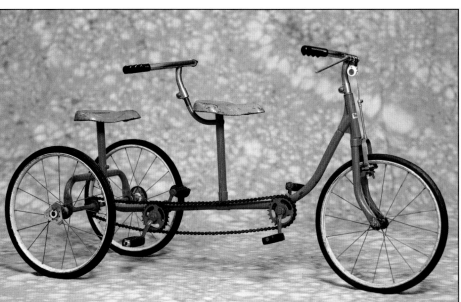
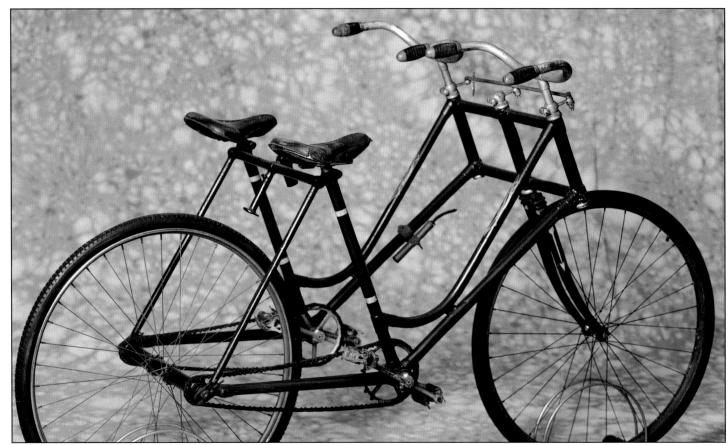

Chapter Four

Tandems, Sociables, and Tricycles

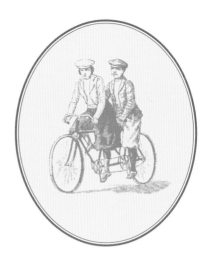

Ordinaries and early Safeties may have garnered most of the attention of bicycle enthusiasts at the time, especially when accounts of speed and distance were published in newspapers. There was, however, a large contingency of the populace that was left in the wake of these dynamic new vehicles. Women, older people, and those who were simply afraid of falling off two-wheeled bicycles did have something to turn to. In fact, they turned to the past, when the early three- and four-wheel velocipedes were the only game in town. By the 1870s, gearing and chain drives were eventually incorporated onto these velocipedes, making them infinitely more rideable.

Women did not have to worry about how they were dressed and whether or not their clothing would become ruined or interfere in the mechanics of these velocipedes, the way they would have if they rode an Ordinary. The older folks knew that they could ride in a tricycle or Sociable cycle without the threat of a small stone appearing unnoticed in their path, tossing them over the handlebars. The amount of exertion was also considerably less, as it was unnecessary to maintain a minimum speed to avoid toppling over to the side. And the non-athletes never had to worry about the possibility, very real, of being far from home and being unable to effectively mount their own bicycle.

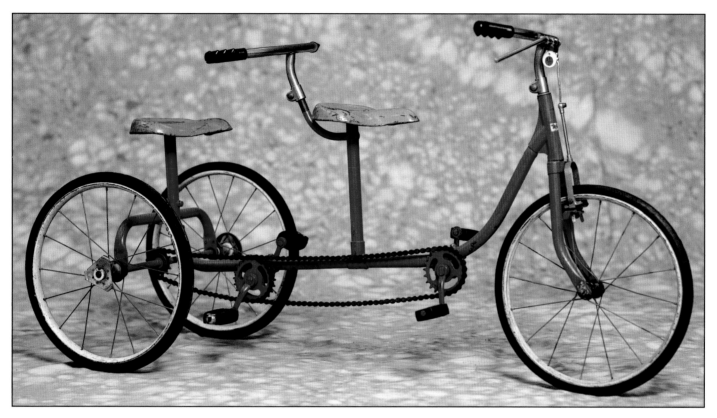

A child's tandem chain drive tricycle with a hand brake at the front wheel.

Many people simply preferred the stability and safety of these "Sociables." They enabled riders to carry more luggage, carry an umbrella overhead, or even enjoy a glass of wine or a meal without ever dismounting. And it came to no surprise to anyone that James Starley of Coventry, England was at the forefront of tricycle and Sociable design. Starley was the first inventor and designer to put the tricycle into mass production. He studied similar machines from the earlier part of the century and incorporated state-of-the-art mechanical designs to make light, durable and safe vehicles for a segment of the population that wanted to experience bicycling without the risk.

The use of tricycles came about in America when two wheels were fitted to a boneshaker in the late 1860s. The American company Pickering and Davis produced a bifurcated perch to which a rear axle could be mounted with two wheels. Without much

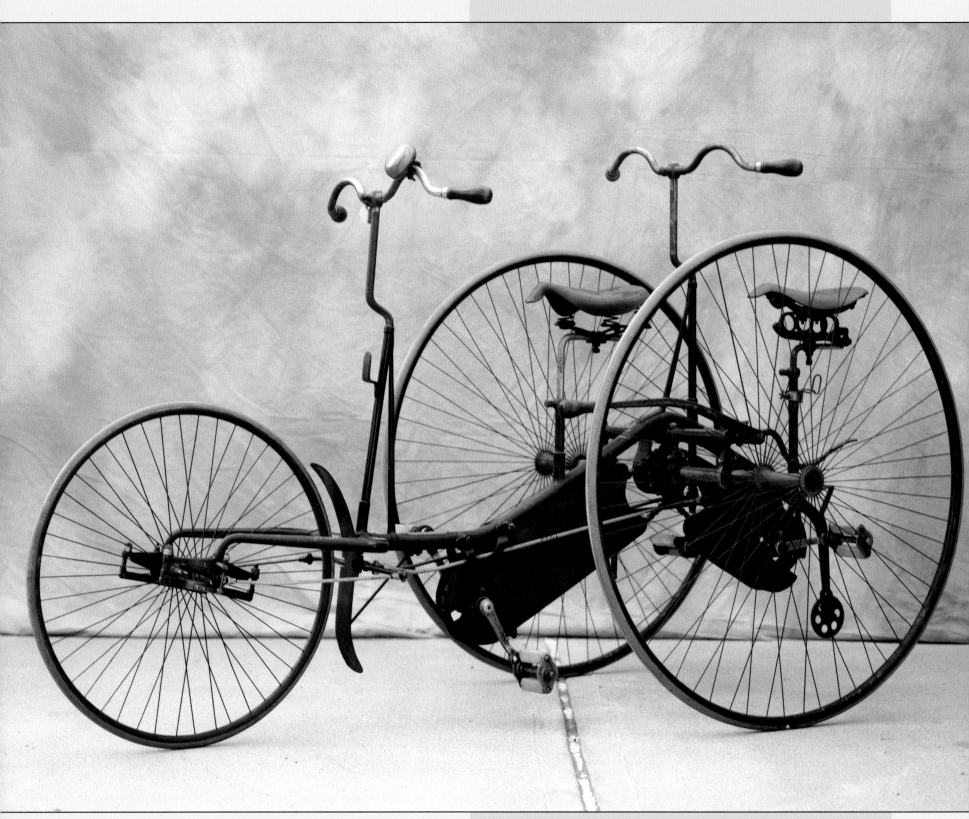

1885 Quadrant #15 highwheel tricycle tandem. It steers front or rear and brakes front or rear. Notice double tie rod steering to two-curved roller tracks at front wheel.

effort, the axle could be removed, and a rear wheel could be repositioned to transform the vehicle back into a boneshaker. These crude tricycles were not the most dependable or sturdy vehicles in the world, but they did offer a more stable ride for those without the gumption to mount a two-wheeler.

There were other attempts at expanding the bicycle market by adding a third wheel to a high-wheeler to create a safer, more stable vehicle. In 1876, William Blood of Ireland created the Dublin tricycle, which featured a large rear lever-driven wheel and two smaller wheels in front used to

"Every time I see an adult on a bicycle, I no longer despair for the future of mankind."

H.G. Wells

In 1872, Starley developed the woman's "Ariel," which was an unsuccessful attempt at giving women the opportunity to ride on a big wheel safely, while wearing a long dress. The design never caught on, but it prompted Starley to come up with a new vehicle—the Coventry Lever Tricycle—a very successful tricycle which was popular for years. This Sociable featured a large wheel, 50 inches in diameter, which rotated by the treadle-and-lever type of mechanism. Two smaller wheels, just twenty-two inches in height, were used to balance and steer the cycle.

stabilize and steer the tricycle. The model was copied by several English companies, leading manufacturers to believe that there would be a public demand for machines that enabled riders to take to the roads without many of the risks of Ordinaries.

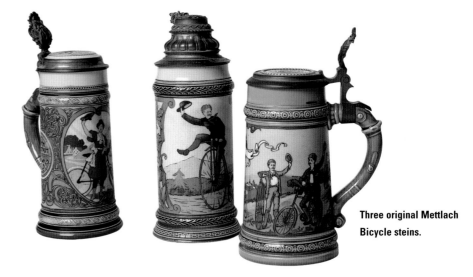

Three original Mettlach Bicycle steins.

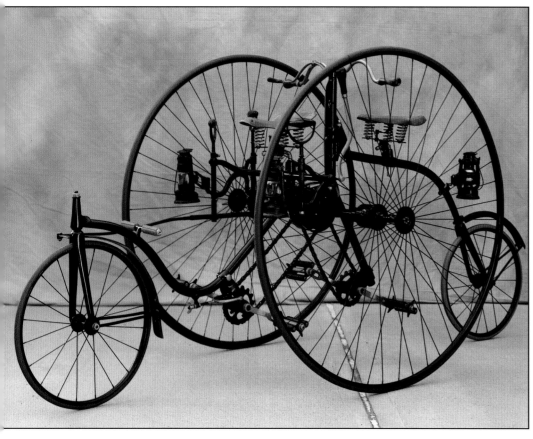

1885 Coventry Club Tandem Quadricycle can be converted to two highwheel tricycles by removing three bolts. By removing one bolt, the rear trailer section is removed and you have a high wheel tricycle with the high wheels in the back and the small wheel in the front. Replace the rear section and then remove the two bolts in front and the front section comes off and you have a high-wheel tricycle with two large wheels in front and the small wheel in the rear. Made by Coventry machinists, Coventry, England.

a machine that swerved uncontrollably as pressure on the wheels constantly varied. In other words, it was incapable of being driven in a perfectly straight line.

Starley's answer to this dilemma was to become the universal solution in cycle engineering. He created a balance gear which would later be described as the "differential." Though the concept had been in use for decades on steam-engines and the like, Starley was the first to apply it to tricycles and quadricycles with his "Salvoquadricycle" and "Salvo Tricycles." What he did was fix the driving-axle with bevel wheels and pinions, allowing power to be transferred to both wheels with balance. It enabled the cycles to turn corners more efficiently, since one wheel was rotating at a faster pace than the other. Automobiles, with their "rack and pinion" steering, make use of this transmission design to this day. The Convertible Sociable was also reversible, where two riders could be seated side by side. In effect, Starley's efforts to design a four-wheeled vehicle with state-of-the-art steering became something of a forerunner to the automobile.

Eventually in 1877, Starley redesigned the Ariel to be a quadricycle, with another large wheel, an extra double-throw crank and endless chains, giving it greater mobility and control. One of the problems with his quadricycle was obvious. Steering around corners with both wheels fixed to the cranked axle needed to be addressed, since the inside wheel would always rotate slower than the outside wheel. This resulted in

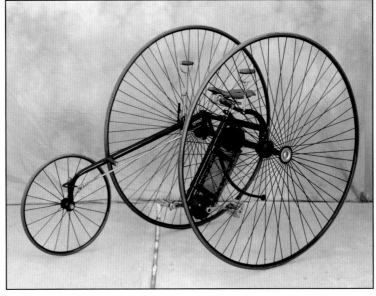

The 1885 Columbia Two-Track Tricycle has 48-inch wheels and was very popular with the ladies and older gentlemen. The ladies, with their long skirts, did not have to climb over any framework to reach the saddle. Made by Pope Manufacturing Co., Boston, MA.

Needless to say, other manufacturers besides Coventry were quick to capitalize on the Salvo technology, implementing it on their own tricycle and quadricycles. Many riders soon discovered that some Sociables were better at climbing hills than many bicycles, and though not as fast, tricycles specifically could hold their own on the open roads, even with a rider of fair skill atop one. Women all over Europe were soon going out for rides with their husbands, and Queen Victoria herself, after seeing a Salvo on the road, commissioned James Starley to design and manufacture the "Royal Salvo."

Another advance in tricycle design occurred in 1877 with the implementation of the loop frame, which was very popular on early tricycles. Attached at the rear axle, a flat or tubular frame ascended forward and a tail was mounted to prevent tipping backwards. These loop frame cycles were powered by pedals on shafts with bearings mounted to the frame. The cycles would have either single or double chains that were attached to the pedal shafts, and they also employed sprockets at the rear wheel. Some of these loop frame tricycles also employed drag breaks that were foot-operated.

Later on, the tee frame, which was similar to the loop frame, featured a center-mounted chain and sprocket, which proved to facilitate a more stable ride. Since the frame was somewhat smaller, it enabled manufacturers to reduce the weight of the tricycle. As designers continued to experiment with frames, the two-track tricycle placed a front steering wheel ahead of the right rear wheel, enabling riders to

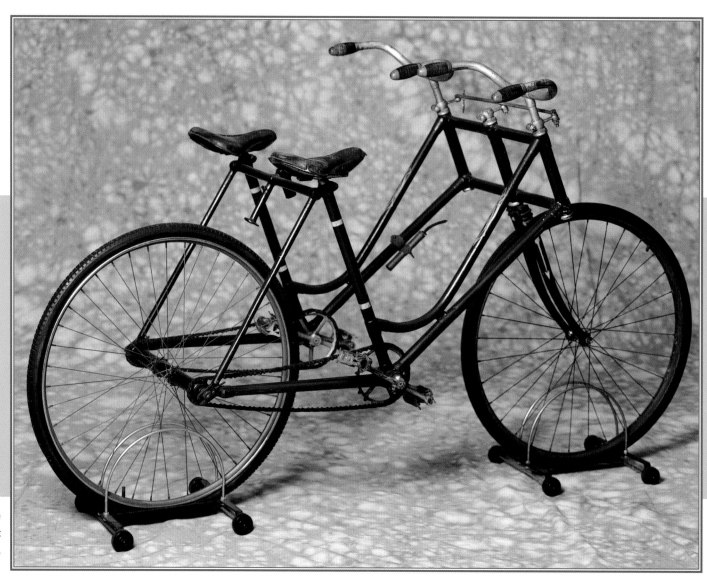

1905 Punnett Companion side-by-side bicycle. Made by Punnett Cycle, Co., Rochester, New York.

avoid the pitfalls of deep ruts, which were common to carriage roads. By opening up the design, riders also had an easier time mounting and dismounting.

In 1877, a front-driving Humber was designed, making it the first tricycle for adults to employ a drive chain located at center-axle. The frame resembled that of an Ordinary, except it featured two large wheels in the front and a smaller wheel at rear-center. Sold as both single and tandem cycles, the Humber pattern was very popular because of its simplicity and safer ride than an Ordinary. But perhaps the most significant and important tricycle design was introduced in 1884 by the British Humber Co. It was named the "Cripper" after R. Cripper, who was the British amateur five-mile champion, notorious for winning numerous races aboard his visionary tricycle. It was a groundbreaking example of direct front steering, which would ultimately prove to be the preferred steering, principle on modern bicycles for the next century. The popularity of the Cripper led to its manufacture of single and

tandem cycles by many companies both in Europe and the United States.

By the 1880s, the tricycle was not just a recreational cycle, but a vehicle that was being used for

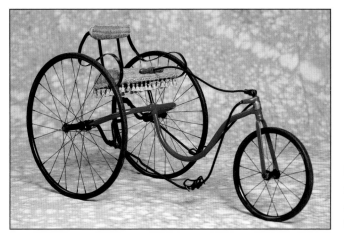

Early Fairy lever drive tricycle with cushioned seat, back rest, and tiller handle steering.

commerce. Businesses, carriers, deliverymen, milkmen and physicians were using them because they offered a speedier method of moving goods and services. One disadvantage of Sociables was that they took up a lot of space, both on the road and when being stored. Later on, tricycle makers attempted to tackle these perceived problems by introducing folding tricycles which could be more easily stored. And Starley himself designed tandem tricycles, which riders rode one behind the other.

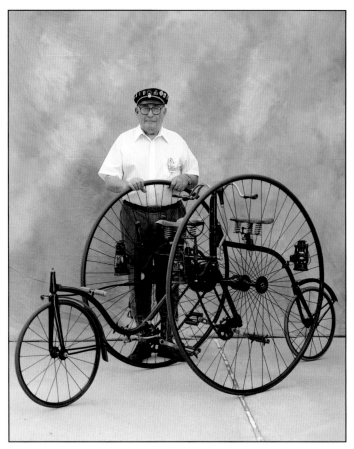

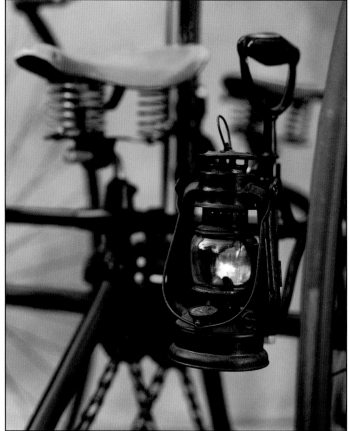

The Coventry Club Tandem Quadricycle

The 1885 Coventry Club Tandem Quadricycle is one of the rarest cycles in the world. It was known as "The King of the World" and can be converted to two highwheel tricycles by removing three bolts. By removing one bolt, the rear trailer section is removed and you have a highwheel tricycle with the high wheels in the back and the small wheel in the front. Replace the rear section and then remove two bolts in front and the front section comes off and you have a highwheel tricycle with two large wheels in front and the small wheel in the rear. As a quadricycle, either rider can control the steering and braking. Made by Coventry Machinists, Coventry, England.

Inevitably, a class war of sorts emerged between riders of Ordinaries and Sociables. Riders of tricycles were known to project an image of snobbiness, claiming that they, as a class, were better behaved than the brutish bicycle riders who lumbered by, sweating and falling constantly on their crude vehicles. Ordinaries and Safeties were, in general, less expensive than tricycles and quadricycles, so Sociable riders, even though they were in the minority, clung to the belief that they were more of a credit to the sport than the primal, less genteel bicycle riders. Royalty and the upper circles traveled on Sociables, they claimed, and therefore they were of a better class than bicyclists.

Conversely, riders of Ordinaries, who were usually more adventurous and athletic (and male) looked down upon Sociable riders with contempt, feeling that they clogged up the roads with their cumbersome, slow-moving vehicles. Regardless of how they felt about each other, one thing was clear: cycling was becoming a much broader activity, involving all members of the family. Tandem bicycles became quite popular, with men and women riding together. The novice rider could allow the stronger or more experienced cyclist to take on the brunt of the work until he or she felt comfortable enough to participate.

More and more women were introduced to cycling through Sociable vehicles and the effect was liberating to them. They were able to wear whatever clothes they wanted while riding, so therefore, they did not suffer the ridicule or ostracism they would

"When the spirits are low, when the day appears dark, when work becomes monotonous, when hope hardly seems worth having, just mount a bike and go out for a spin down the road, without thought of anything but the ride you are taking."

Arthur Conan Doyle

have felt had they dressed more practically for riding atop an Ordinary. Naturally, there was a great deal of attention being paid to the manners of bicycle riding by the late 1880s. Society columns listed "Do's and Dont's" for women when cycling, such as "Don't ride without gloves," and "Don't ride a tandem cycle on a Sunday afternoon without a male escort." On tandem bicycles, it was expected that the woman should ride in the front which enabled her to see the countryside more clearly without the broad back of a male blocking her view. It also allowed the presumably stronger male to take on the brunt of the peddling while seated in the back. On the other hand,

women who sat up front were also responsible for steering the vehicle, and many cyclists at the time felt that women did not effectively navigate cycles in heavier traffic. Not only was she doing the steering, but if the cycle built up any speed, she was also acting as the windbreaker for her male counterpart in the back.

Some tricycles placed the woman backward on the cycle, which seemed to regard them as some sort of delivery product rather than possible mate. This positioning practically discouraged communication between the riders, but adhered to the dignity the Victorian classes expected. Some manufacturers

adhered as well, creating features on their vehicles that offered the comforts of Victorian morality. Bayliss, Thomas and Company fitted their cycles with the "Beatrice Shield," which protected a lady's ankles from being exposed by the wind. Other manufacturers struggled with the issue of fitting a proper seat for a lady on a tricycle. A saddle, some said, was not proper for a lady to be seated upon. However, as women became more comfortable on these cycles, the more they clamored for equality and paid no attention to the etiquette.

It is difficult to imagine the impact of women and cycles on society in the nineteenth century. For nearly three decades beginning in about 1870, questions were raised regarding a woman's right to ride, the clothes they should wear when riding, the moral implications regarding their decision to ride, the impact on their health, their riding technique, and what kinds of bicycles they should ride. The argument may have played itself out in terms of women and bicycles, but the debate really centered around women's rights in general. As the bicycle developed, women were relegated to watching husbands and sons take their bicycles out on weekends, as cycling was deemed a male activity. While most women accepted this, other women clearly felt they were being deprived of something.

In order to satisfy their longings, however minimal at the time, some bicycle manufacturers made

Child's Early Tricycle has steering handles on each side, which control the rear steering wheel. The two foot levers connected by leather straps to the offset axle propel the tricycle forward.

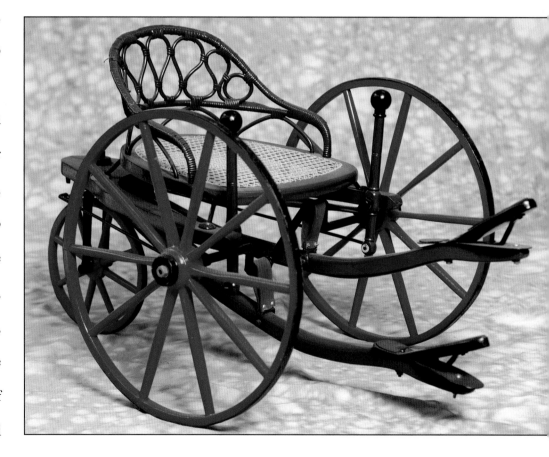

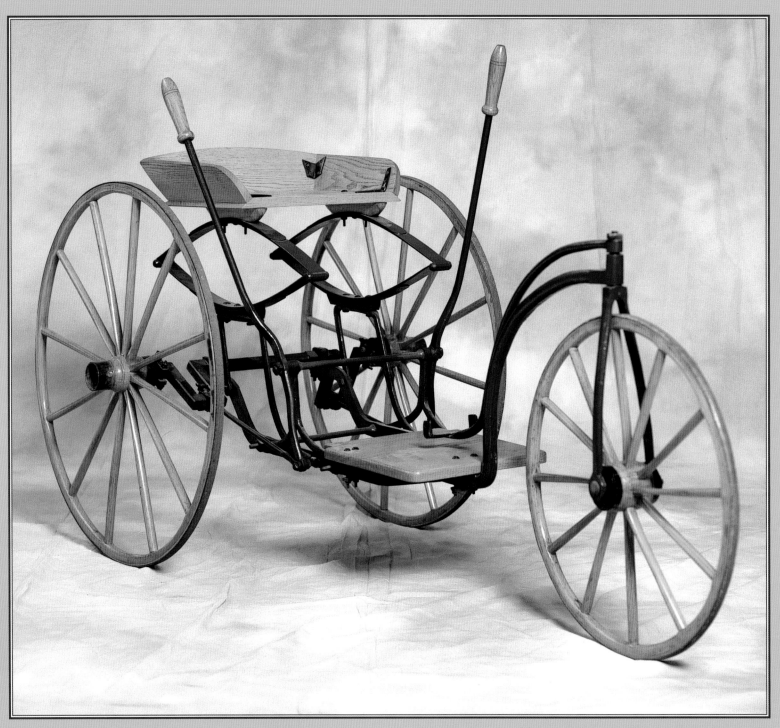

The 1870 Tri Wheel Cycle has rear pawl and ratchet drive wheels operated by back and front action of two hand levers.

hobbyhorses for ladies as far back as 1818. But it was not very common for women, in Europe at least, to have ventured out on any type of velocipede up until the 1860s. Ironically, women might be employed in factories, sweatshops or even as mineworkers, but the idea, to many men, of women exerting themselves on a bicycle was considered unseemly. They were ridiculed in editorials and cartoons of Europe at the time, and though there was less resistance to women making use of bicycles indoors for methods of exercise, a venture out into the fresh air was likely to see her greeted with more than surprise by male cyclers. One factor that contributed to the European woman's dilemma was related to fashion. The long skirts they wore did not mix well with the design of bicycles at the time. Some makers, such as Samuel Webb Thomas, designed a velocipede with a seat, enabling a woman to ride the way she might ride a horse— sidesaddle. The velocipede never caught on, however.

In America, women fared much better. Already, the public was aware of women's suffrage and American women had garnered a reputation of being more independent-minded and strong-willed. They were less likely to submit to societal pressures than their European counterparts. Still, it took the invention of the Sociable to bring women out en masse to the roads.

In spite of the invention of the Safety bicycle, Sociables did not die as sudden a death as one might imagine. As late as the 1880s, Sociables, tandem bicycles and "Quadrants" were used as touring machines, built for comfort and practicality because one could carry luggage as well as other traveling necessities. People began biking all over England and Europe on Sociables, and before long, tricycles began to get the respect, even from bicycle riders, that they deserved. However, Safety bicycles would eventually capture the market as young and old alike felt comfortable riding them. And once women decided that they too wanted to ride two-wheeled bicycles, the Sociable's lure over the refined and genteel masses waned.

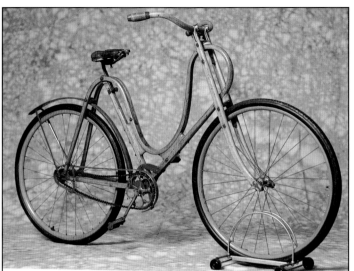

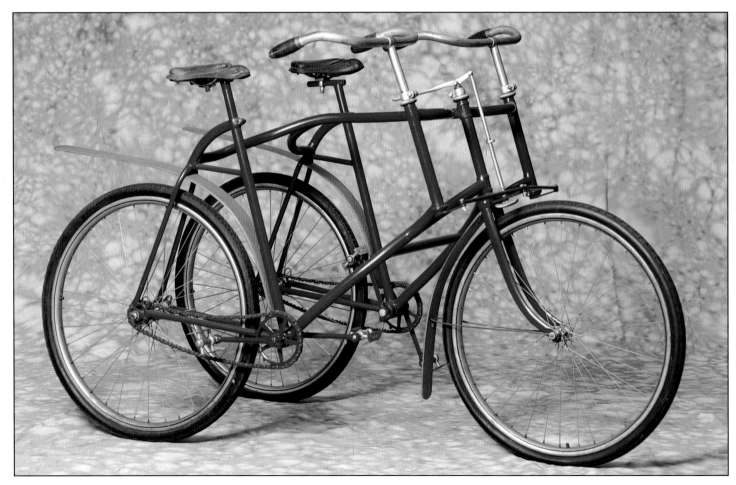

Chapter Five

The Booming Nineties

Because the Safety was so popular around the world, almost all design improvements and inventions were geared toward the growing numbers of two-wheelers taking to the roads. The enhancements in bicycle technology in the late 1880s enabled literally hundreds of manufacturers to profit from the exploding interest in cycles. High-quality bicycles could be bought in a very competitive market for under $100, and the amount of bicycle accessories available was equally as staggering.

By the 1890s, otherwise known as the "gay 90s," America was under the spell of a bicycle craze. It was a craze that lasted for decades and reached such proportions that it was no longer referred to as a fad.

Cities began building better roads and designed parks with pathways specifically for bicycles. A spring weekend in any urban park was likely to produce wheel-to-wheel bicycle traffic, and such was the case in all major cities across the country. But nowhere was bicycling as popular as in Coney Island in Brooklyn, New York. While it can clearly be said that cyclists in Brooklyn were equally as passionate about their Ordinaries a few decades before, there was no way to describe how enthusiastically they took to the new bicycles of the 1890s.

One of the major factors in their excitement could certainly be linked to the quality of roadways available. Coney Island Boulevard had unique paths

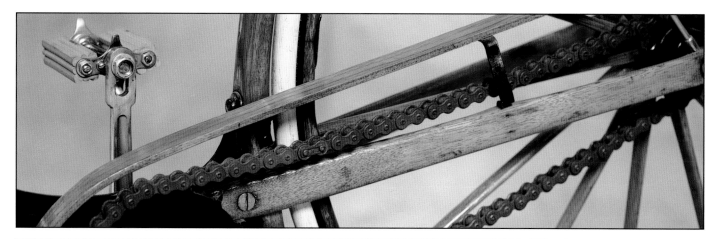

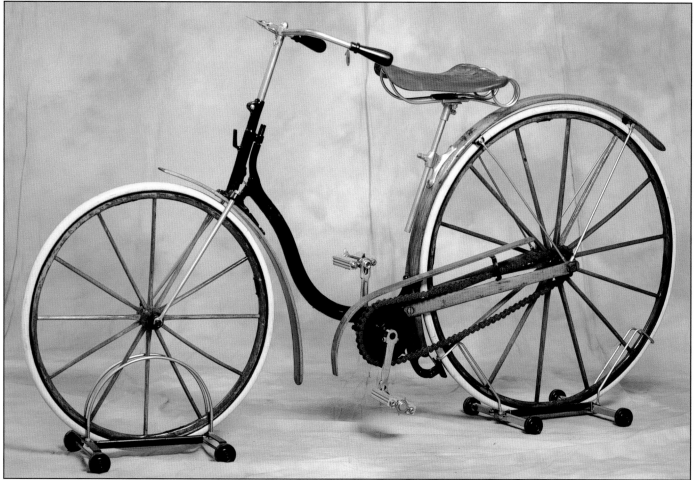

The 1891 Lady's Elliott
Hickory hard tire
safety is complete
with hand brake,
wood wheels, wood
frame, and chain guard.

that ran parallel to the boulevard for over five miles. With the Atlantic Ocean nearby, the hearts of cyclists were clearly moved by the idea of a refreshing ride by the seashore and the salty air. "Speeders" as they were called, pedaled down the Boulevard in every sort of bicycle imaginable—from tandems and quadruplets—to even the more traditionalists atop their Ordinaries. But mostly, they rode two-wheeled bicycles, and they did so by the thousands.

They took to the roads in their bloomers and their knickers. If the speeders went too fast, they were likely to be chased and chastised and even fined

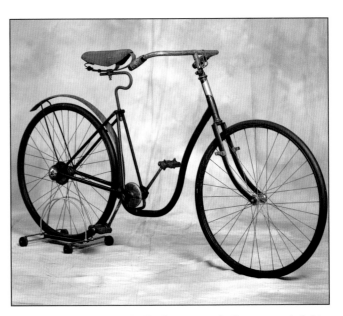

The 1892 League girl's bicycle. The League was the first gear or shaft drive bicycle made in the United States. Made by League Cycle Co. of Hartford, CT.

for their efforts. The annual parade in Coney Island attracted bicyclists from up and down the eastern seaboard and beyond, as well as thousands of spectators who attended for the amusement alone.

All across America, bicycling clubs were sprouting up and there wasn't a 4th of July parade that did not include some sort of bicycle contingency. Large public celebrations were sometimes organized for no other reason than to create a procession of bicycles. In 1896 in New York, it was estimated that some 12,000 cyclists pedaled down Riverside Drive, many of them wrapped in the American flag, in front of

"Get a bicycle. You certainly will not regret it, if you live."

Mark Twain

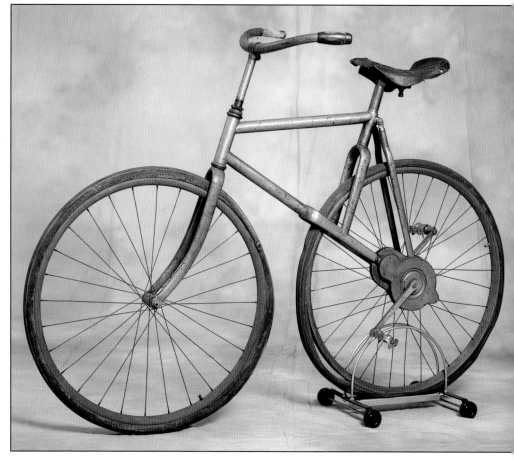

The 1890s Bronco Type Bicycle has no chain nor sprocket, but comes equipped with a short frame, wood rims, wood handlebars, seat placed directly over cranks, and a gear drive direct to rear wheel. A very rare and unusual bicycle.

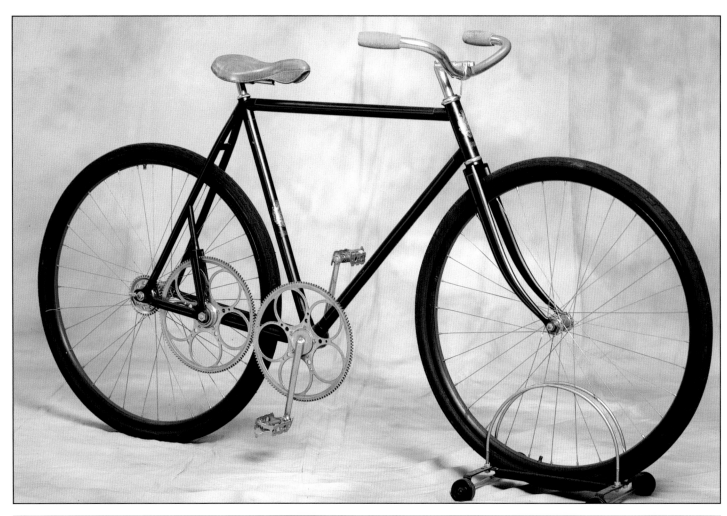

The Carroll Chainless-Spur Gear Drive was patented in 1897
by Carroll Chainless Bicycle Co. of Philadelphia, PA.

over 100,000 people. The majority of riders aboard one of hundreds of Safety bicycles available on the market. In the parade, members of the Michaux club engaged in an activity known as "Balaklava Melee," where they reenacted the charge of the Light Brigade. The best riders wore fencing masks and batted each other with canes—the last man standing being the winner. The ladies engaged in "ten pin rides" where they serpentined through a line of bowling pins. Relay races, fancy riding and even bicycle dancing was performed.

The Mercury Wheel Club in Long Island was known for organizing a night parade with lanterns, and giving awards for the most visually appealing cycles. Decorating one's bicycle was also a popular endeavor for those cyclists who enjoyed taking part in parades, as much as trick riding was to others.

There was little doubt that earlier bicycle enthusiasts were often members of the upper classes. By the 1890s it was difficult to make any social assumptions about cyclists. They ran the gamut,

from academics to laborers to millionaires. While John D. Rockefeller toured the great universities on a bicycle, delivery boys in Chinatown were already making their rounds atop two-wheeled cycles. The first National Bicycle Show was held at Madison Square Garden in New York in 1895, and manufacturers displayed thousands of bicycles for consumers to see and test-ride. There, the Tribune, a bicycle that weighed less than nine pounds was unveiled, and the

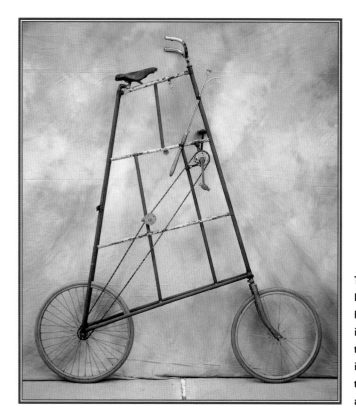

The 1894 Lamplighter Bicycle is 8 feet high and was used in the 1890s to light the street gas lights in many cities. Notice the lighting torch attached to the frame.

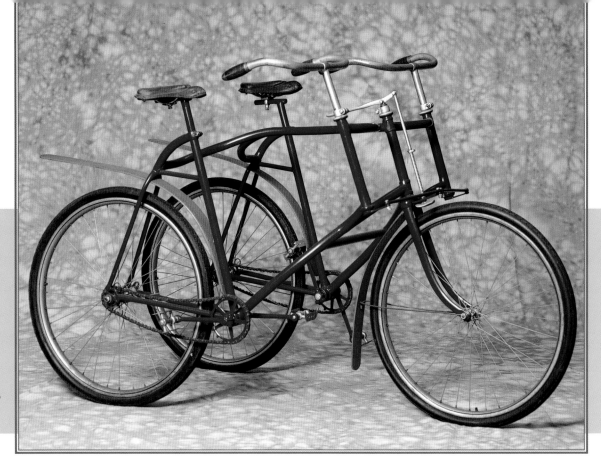

1898 Wolff American Duplex
Tricycle. Made by Wolff
and Company, Limited, NY.

public was stunned. Up until then, bicycles, though considerably lighter than Ordinaries, were still somewhat heavy and cumbersome by today's standards. But the Tribune was a staggering piece of design work. It was every bit as big as the bicycles of the time, with 28-inch wheels and extraordinarily sturdy as well. However, the Tribune never reached the level of popularity one might have suspected, given its attributes.

Bicycling was not just an East Coast pastime, either. Across the country in Los Angeles, bikers had every reason to celebrate as much as their Coney Island counterparts when the Pasadena and Los Angeles cycleway made its debut at the turn of the century. The cycleway was probably the first ever superhighway, as it provided a perfect road with very little gradation stretching the nine miles between the two cities. Built with wood, the road was elevated and also lit with incandescent lights every block or so, making it fit for riding in day or night.

By the 1890s, bicycles had come to take on a modern form. Most had a diamond-shaped frame, a rear-wheel chain drive, and pneumatic tires, and were fast, comfortable and most importantly,

affordable for almost anyone who wanted one. That is not to say that there weren't unique features and designs at the time. In 1897, Thomas Carroll of Philadelphia presented the Carroll Gear-to-Gear bicycle, which had three sprockets, one of which attached to the crank, one to the rear-wheel hub and one to the chain stay. With a diamond frame, the Carroll Gear-to-Gear was efficient and sturdy, but like many innovative designs of the time, it was never developed.

Before the turn of the century, it was estimated that there were over 3,000 American companies in the business of bicycles—producing everything from cycles and parts to accessories. In 1897, over two million bicycles were sold. Advances in designs were attacking the market at a staggering pace. Just a few years before, Charles Kingston Welch, a Scotsman, and an American named William Erskine Bartlett both patented techniques of fixing tires to the rims. Welch employed a detachable cover with hidden wire edges, while Bartlett worked with a clincher that locked the inflated tire into grooves in the rim. Ever

the opportunist, John Boyd Dunlop acquired both patents and used both designs in production, enabling Dunlop's company, the Pneumatic Tire Company to capture the overwhelming majority of market share.

The pneumatic tire was constantly being improved upon from Dunlop's original design in 1888. By the early 1890s, Colonel Albert Pope of the Pope Manufacturing Company, had produced his own version of the tire—a single-tube inflatable which became known as the "hose pipe." Pope and

The 1896 Bentwood Bicycle's entire frame is made of one length of wood which is bent to shape. The ends were split in half to create the rear forks.

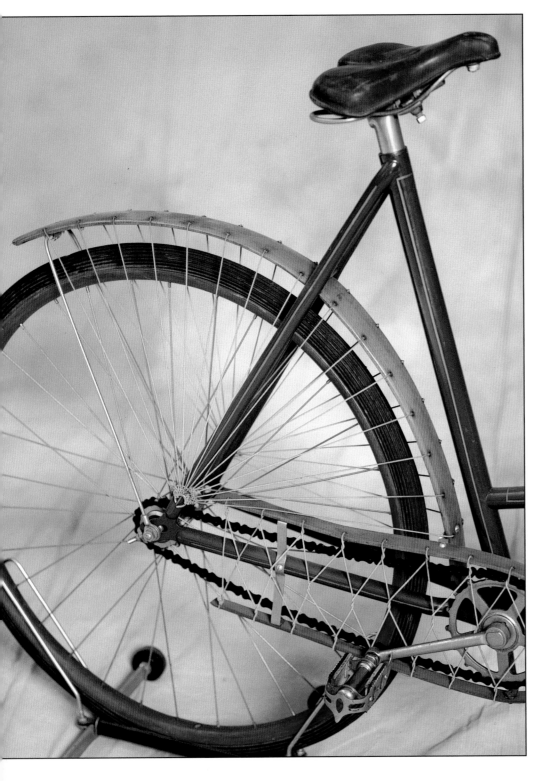

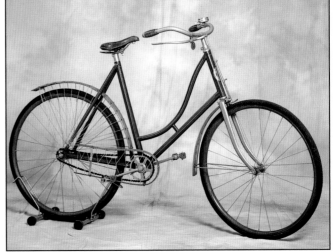

other companies soon found a way to create "puncture-proof" tires (which rarely was the case!) that captured the imagination of cyclists everywhere. Pneumatic tires were constantly being improved upon, and one of the ways manufactures attempted to publicize their new and improved tires was by sponsoring racers. If, they believed, the fastest cyclists in the world could win with a certain set of tires, consumers would be influenced.

In 1891, a cyclist by the name of Charles Terront used tires made by Michelin to win the Paris-Brest race, finishing over eight hours ahead of his competitors, despite the fact that one of his tires had

The 1897 March Davis girl's deluxe bicycle. Complete with wood fenders and chain guard, hand brake to front wheel, leather wrapped grips and wood rims.

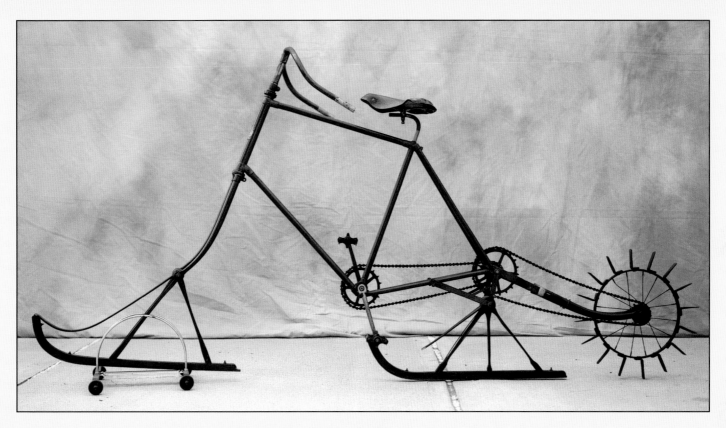

Ice Bike

The 1894 Cleveland Bicycle converts to an ice bike. In the winter, the wheels are removed and two sled runners are attached. The rear paddle wheel is connected by chain from the rear wheel sprocket to the paddle wheel sprocket. A spring action keeps the sharp paddle wheel pressed to the ice. Activating the pedal crank turns the paddle wheel which propels the ice bike forward.

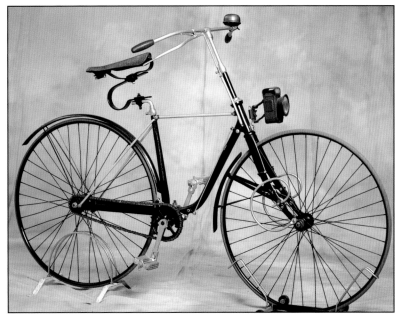

(top left and right) The 1891 Lozior and Yost Deluxe Model #4 convertible hard-tire safety bicycle complete with front and rear fenders, hand brake with linkage to rear wheel, spring action front fork, kerosene head lamp, mounting step and bell.

The 1898 Rex three wheel cycle has a floating rear wheel is designed to absorb bumps in the road and produce a smoother ride. Has Elmore Roller sprockets. Made by Rex Cycle Co. of Chicago, IL.

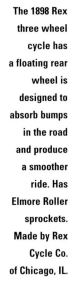

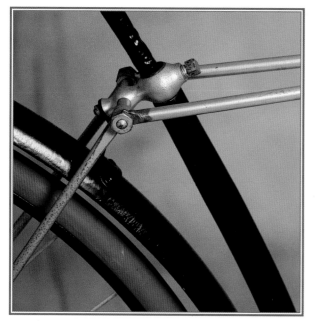

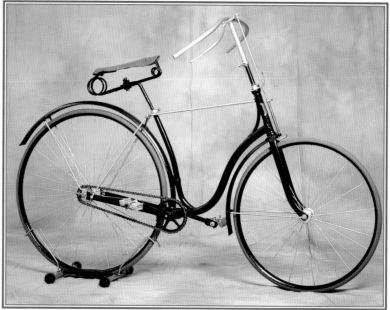

1891 Hard tire safety bicycle complete with front and rear fenders, hand brake to front wheel, and removable top bar to convert to girl's bike.

been punctured and had to be repaired during the race. But the following year, another race was organized, this time by Edouard Michelin himself. The race was complicated by the obstacles Michelin chose to incorporate. He placed rows of nails throughout the racing route, exposing all the riders to flats along the way, making it so that the race was decided by not the fastest rider, but the cyclist with the easiest tires to repair. Henri Farman won, riding on Michelin tires, but there is no record of the other manufacturers included in the race.

The 1890s also saw developments of other types of bicycles that sought to improve riding conditions. While pneumatic tires certainly lessened the bumps along the way, many riders continued to believe that vibrating was a problem that demanded the attention of designers. Cork and leather grips were added to the handlebars in the hope of alleviating the vibration, as well as "ram's horn" bars and others. The Elliott Hickory Bicycle Company chose not just to experiment with the handlebars, but to design bicycles made almost entirely of hickory. But it turned

placement of sprockets, hoping to stumble on some improvement that would help separate their bicycles from the competition. Perhaps the area of bicycle design that became the most tinkered with was the gearing. The science of gears fascinated the public, and manufacturers attempted to tap into this by making extravagant claims regarding the superiority of their gear science. In 1893, Century Columbia's Model 32 came equipped with a new elliptical front sprocket, which was significant in that the higher gear was operative not just in the ideal position for the crank, but also at the most powerful position when the rider's leg was exerting energy and extended. In short, the elliptical sprocket made it possible to extend the time of exertion and reduce dead areas of propelling power.

Columbia produced a new bevel gear shaft-driven chainless system which was popular, and Victor introduced their Straight Line Sprocket, which used an innovative cut of the sprocket teeth, spreading the teeth out so that mud and dirt would be less likely to

out that wood did not do much to limit vibration after all, and companies such as The Old Hickory Cycle Company eventually returned to the manufacturing of furniture.

Companies continued to experiment with designs and redesigns in steel tube frames, suspension and

clog the chain. The next year, in 1899, Victor introduced its Spinroller which was a chainless patent consisting of two sets of rotary roller teeth that meshed together, transmitting power from the cranks through the shaft located inside a hollow rear fork. Though many manufacturers experimented with chainless technology, it was more expensive to produce and it was ultimately decided that it did not make bicycling any easier.

Another area of improvement on bicycles was the advent and improvement of braking systems. Once again, Columbia was at the forefront of this technology. The introduction of the Columbia New Departure brake was significant in that it slowed and

"I relax by taking my bicycle apart and putting it back together again."

Michelle Pfeiffer

The 1892 Wood Wheel Bicycle has a steel tubing frame and wood wheels and fenders; made by Gendron Iron Works.

The 1893 Boy's Elliott Hickory with wood wheels and spring-action front fork.

eventually halted the rear wheel by basically attempting a backpedaling motion. Now, it was no longer necessary to attach a brake spoon or a complicated rod system. The New Departure system enabled a rider to coast simply by resting his feet on the pedals, much like on the bicycles of today. Remarkably, there was some resistance to buying a bicycle with a brake, especially amongst the young "speeder" set. But Columbia marketed the New Departure very effectively, taking great pains in advertisements to explain that the brake's technology was hidden within so that it would not be noticed.

Two brothers in Dayton, Ohio were also concerned with improving upon the design of bicycles. Orville and Wilbur Wright designed the Wright Van Cleve in 1896, which was a state-of-the-art, 22-pound bicycle that sold for just $65 dollars at the time. The Wright brothers designed the frame and most of the components came from the top-shelf manufacturers. The Wrights, though successful, did not manufacturer very many of their bicycles. However, many

of their cycle principles were used to develop the airplanes, such as steel tubing and chain drives.

The bicycle boom was in full force by the end of the 19th century. Bicycles had come down in price over the decade, but they were still costly to many

This 1894 Columbia has 34-inch wheels with 1 ¼" x 34" pneumatic tires. It was made one year only and on special order. A special bike for tall people. Notice the 34" cyclometer at the front wheel fork.

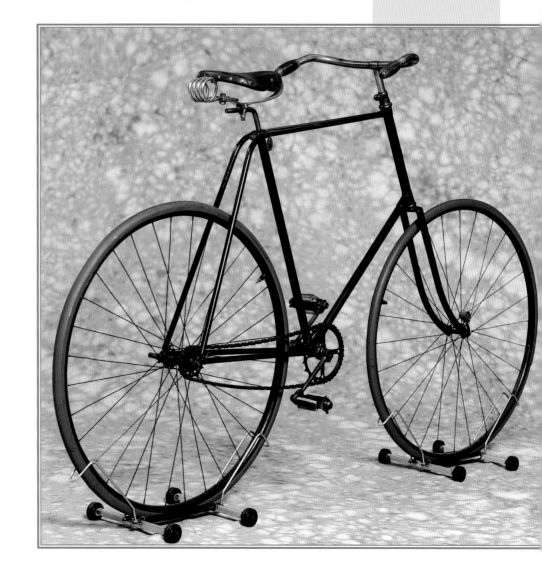

Close-up of hand brake and removable top bar to convert to a girl's hard tire safety bicycle.

and it required some planning or sacrifice for the average person to purchase one. Watchmakers and piano manufacturers complained that people were no longer saving to buy those products, and theater owners also noticed a drop off in attendance on sunny days. The economic impact was very clear. But the effect on religion could not be understated. Bicycling was interfering with worship at church, prompting clergymen everywhere to rally against the cycle.

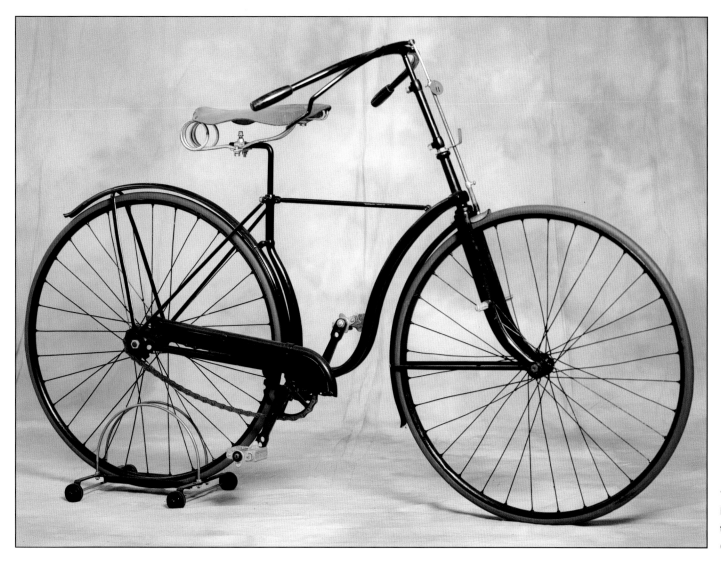

All across American cities and the countryside, horses began to vanish from the landscape. Priced about the same as a bicycle, but much more expensive to store and maintain, the economic effect of cycles on the horse trade escaped no one. Although in fairness, it's important to point out that the bicycle was not the death knell for the horse. A craze of a different kind—the automobile craze—would ultimately replace the horse. And ironically, the bicycle boom of the 1890s was about to fall prey to inevitable market forces.

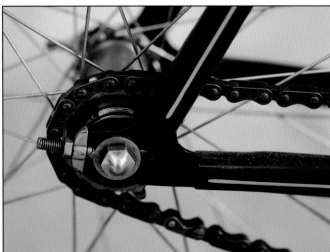

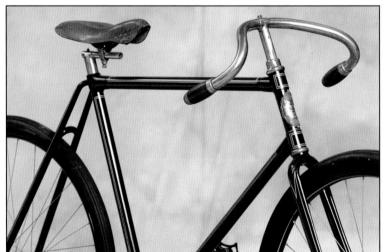

The Racers

While America may have been completely under the spell of the bicycle craze of the 1890s, it is fair to say that there was already a group of highly dedicated bicycle enthusiasts around the world. They were a group that relished, revamped and put to the test every mechanical advance that came down the pike. Manufacturers may have attempted to trick the general buying public with fancy claims of comfort, durability and speed, but there was one segment of the public that could not be fooled, and companies bent over backward for their endorsement. They were the racers and they were a major factor and driving force behind many of the technological improvements of the bicycle ever since

Baron Karl von Drais first unveiled his Draisines on an incredulous public.

While it is fairly certain the bicycle races were staged independently and without much fanfare as far back as when the first self-propelled vehicles came into existence, curiously, the first documented velocipede race occurred in France in 1868. On May 31, 1868, a British veterinarian by the name of James Moore won a twenty-five kilometer velocipede contest in St. Cloud, not far from Paris. A few months later, six Americans and six French riders competed in a race consisting of "two laps" for a prize of 1,000 francs. There was no telling where or how long the laps were, but the rules of the race were

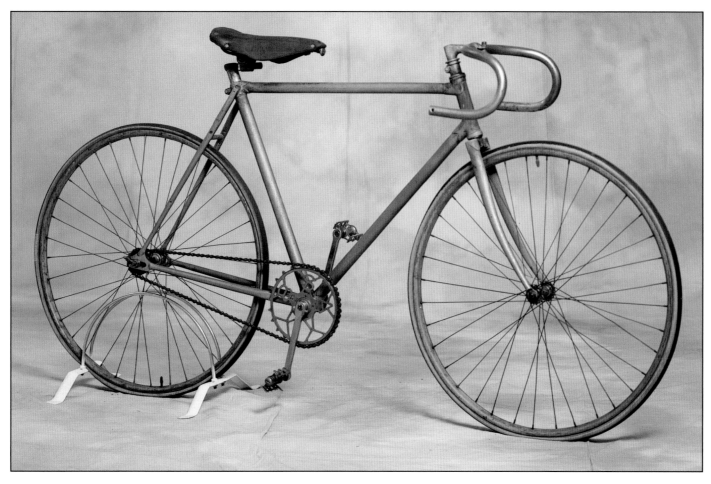

An 1899
Columbia Racer.

quite clear. Riders weren't permitted to touch their feet to the ground during the course of the race.

In 1869, long distance races began to capture the imagination of the public, and on November 7, two hundred riders competed in an 83-mile race, the winner, once again, was James Moore, who logged a time of about ten and a half hours. Remarkably, Moore covered this distance on an Ordinary with a front wheel of about 60 inches. Spectators were drawn to these races not only to see Ordinaries pushed to their limits, but also because a "header" off a high-wheeled racing cycle was a spectacular sight. It was not uncommon for riders to break bones during the course of a race. In fact, Reggie McNamara, a New

Jersey racer claims to have broken his collarbone no less than fourteen times—and McNamara was considered one of the premiere racers of the time!

McNamara made a name for himself in "six-day races" which were most popular in Britain, but becoming more common in America by the 1870s. In one such race in England in 1875, Frank Waller rode for an average of eighteen hours a day to win at the Agricultural Hall in Newcastle. Soon, racers began to adapt to racing on Safeties. They took the

An Alenax Racing bicycle. Made around 1990, it has a unique transbar power system with part chain and part lever action drive.

possibility of a catastrophic fall off the table, but fans still flocked to these events in great numbers. The races were held on oval tracks and by the 1890s, became extraordinarily popular, as fields were increased so that a pack of racers set out for the prize. Sponsored by bar owners and even bookmakers, the races were sometimes held indoors, or under large, circus-like tents with wooden tracks. In 1891, Bill Martin, known as "Plugger" captured a $2,000 prize at Madison Square Garden when he rode nearly 1,500 miles in only 142 hours.

Twenty hours of straight pedaling with very limited rest was finally outlawed, but not before a racer by the name of Charlie Miller captured the imagination of the public for one last time in 1898. Miller, a German immigrant who put down roots in Chicago, was notorious, not only for the distances he covered in six-days, but for his passion for theatrics as well. Known as the "King of the Single Sixes," Miller had an alter set up in the infield of the New York track, where he proceeded to marry his beloved

"Nothing compares to the simple pleasure of a bike ride."

John F. Kennedy

A King of the Single Sixes trophy.

during a break in his cycling. Miller reportedly donned a special riding outfit for the occasion (pink with white tights), which no doubt endeared him to the press at the time, for Miller still managed to win the race!

Women entered "sixes" but the amount of consecutive time they were permitted to ride was regulated by racing officials. They competed only against other women riders, and Frankie Nelson was so successful in these races, that she was dubbed "Queen of the Sixes" by the end of the century. The promotional aspect of cycling feats was invaluable to bicycle manufacturers. Just a decade before Safety races became the buzz of the cycling world, Colonel Pope and *Outing* magazine, a magazine devoted to cycling, sent the English champion rider Thomas Stevens on a high-wheeling ride around the world. Pope saw to it that Stevens provided a journal from his travels, excerpts of which were published in *Outing* over the nearly three years it took to complete his journey. The installments garnered Stevens a great deal of attention and catapulted him into stardom. Beginning in San Francisco, he was given a sendoff worthy of an explorer, and his journey

"It is by riding a bicycle that you learn the contours of a country best, since you have to sweat up the hills and coast down them. Thus you remember them as they actually are, while in a motor car only a high hill impresses you, and you have no such accurate remembrance of country you have driven through as you gain by riding a bicycle."

Ernest Hemingway

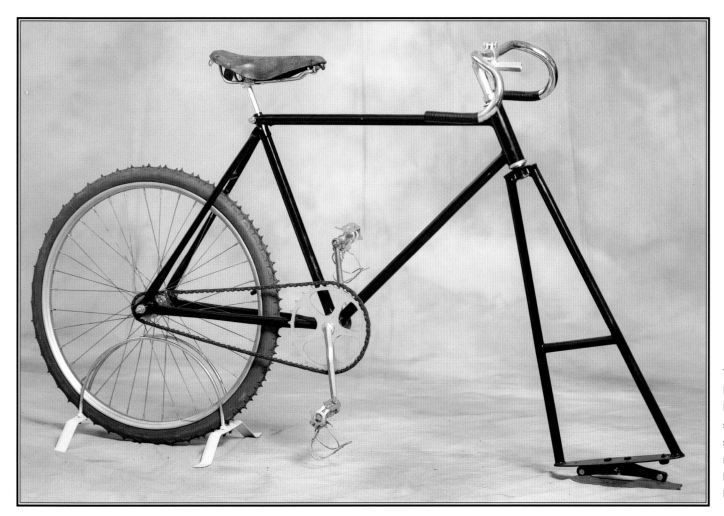

The 1910 Ice Racing Bicycle with a skate blade in front for steering and sharp steel studs in the rear tire was made by Pop Brennen, Irvington, NJ.

through America's west brought him face to face with cowboys and Indians and adventures galore. In Europe, Stevens's fame had preceded him, and he arrived to throngs of women who offered themselves as brides. Stevens kept pedaling, and when he reached Asia, his adventures became more and more dangerous. Swarthy-looking men as well as wild dogs accosted him at unsuspecting moments, but Stevens was able to produce a pistol he packed for the journey, which kept him out of trouble. Remarkably he made it back to America where he was once again given a hero's welcome, but ironically, his

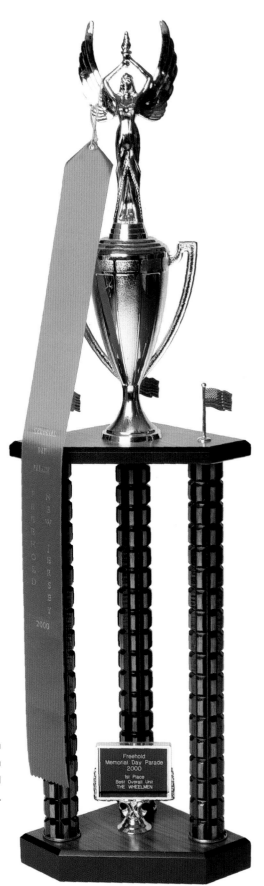

36-inch first place trophy won by the New Jersey Wheelmen at the Year 2000 Memorial Day Parade in Freehold, NJ.

membership in the League of American Wheelmen had expired, and Stevens was banned!

The Pullman Road Race in Chicago had many bicycle enthusiasts wondering if racing would ever be the same. Originally staged with the premise that the riders would chase after a "rabbit" and the route the rabbit took to Pullman, a Chicago suburb, became the course for the race. By 1895, the race had reached epic proportions. Over 500 cyclists took place in the contest, and only five of them started from scratch. The rest of the field was given head starts as a means of handicapping the field.

When the race finally began, the cyclists roared into Lincoln Park with such ferocity that once one rider, H.J. Jacobs fell from his bicycle; the other cyclists had no choice but to go over him. By the end of the race, over 50 riders would go down, and Homer Fairmon was declared the winner. Immediately, however, a protest was lodged. It was alleged that Fairmon, among other charges, did not ride the full course, and an investigation later proved that

he had indeed "short-coursed" his way to victory. By the end of the inquiry, nearly two dozen racers were disqualified.

Manufacturers soon discovered that lightweight bicycles would increase a racer's performance. Sprocket sizes increased, better bearings were affixed and advances in pneumatic tires were significant improvements to racing bicycles. Promoters constructed smoother and better track surfaces, the racers themselves began training their bodies to increase endurance, and racing tactics such as the use of pacers all helped contribute to faster times.

One of the first great American cyclists to achieve stardom on a worldwide basis was Arthur A. Zimmerman, an athletic, easy going racer from New Jersey. Zimmerman was the dominant amateur racer during the 1890s, with a penchant for fine cigars, good conversation and distaste for the kind of training that many riders had already begun to consider essential in racing. Zimmy was an extraordinary athlete with powerful legs, and his preferred tactic

"The world lies right beyond the handlebars of any bicycle that I happen to be on anywhere from New York Bay to the Vallee de Chevreuse. Anywhere is high adventure, the walls come down, the cyclist is a loner, it is the only way for him to meet other loners. And it works. One seldom exchanges anything but curses or names of insurance companies with another driver, the car inhibits human contacts. The bicycle generates them; bikes talk to each other like dogs, they wag their wheels and tinkle their bells, the riders let their mounts mingle."

Daniel Behrman
The Man Who Loved Bicycles

was to stay within striking distance of his opponents, then reach back at the end of the race with a sudden burst of speed that his fellow riders simply could not match. Remarkably, he was able to employ this strategy no matter the distance of the race. In 1892, Zimmerman traveled to England to compete against the world's best riders. He quickly won over the

European cycling enthusiasts by winning the English national championships at three different distances, the one mile, five mile, and twenty-five mile contests. But Zimmy was not done. Further cementing his greatness, the 22 year-old American entered the fifty-mile race—a race where it was assumed he would not be able to use his furious

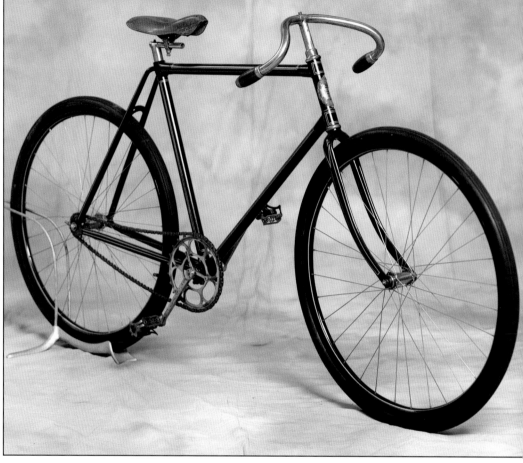

finishing bursts to much success, given the length of the ride. Yet that is precisely what Zimmerman did. He rode behind the British favorite, Frank Shorland until the final stretch, and then simply turned the race into a sprint, and Shorland could not keep up.

Zimmy became a cycling star of world renown, and the endorsements flowed in, quickly putting an end to his amateur status. The British bicycle manufacturer, Raleigh, signed Zimmerman to a lucrative contract, and the "Flying Yankee" had little choice but to race professionally, which he did with great success as well. Still, the League of American Wheelmen, a purist organization for bicycle riders,

Arthur A. Zimmerman was the world's first bicycle racing champion. He held the championship many years during the 1880s and '90s. When he retired in 1895, he opened the Arthur A. Zimmerman Cycle Co. in Freehold, NJ, and manufactured several models of the Zimmy bicycle.

struggled with professional racers, and they were not comfortable watching Zimmerman convert past glories on the tracks and roads into commercial acclaim. Also of particular concern was Zimmy's endorsement of a British company, rather than an American one. The bicycle boom was beginning to wane, and the L.A.W. felt Zimmerman should help revive an American company in tough times.

By 1897, Zimmerman retired from racing and put his energies into a bicycle company which bore his name—The Zimmerman Manufacturing Company—based out of Freehold, New Jersey. The bicycles he

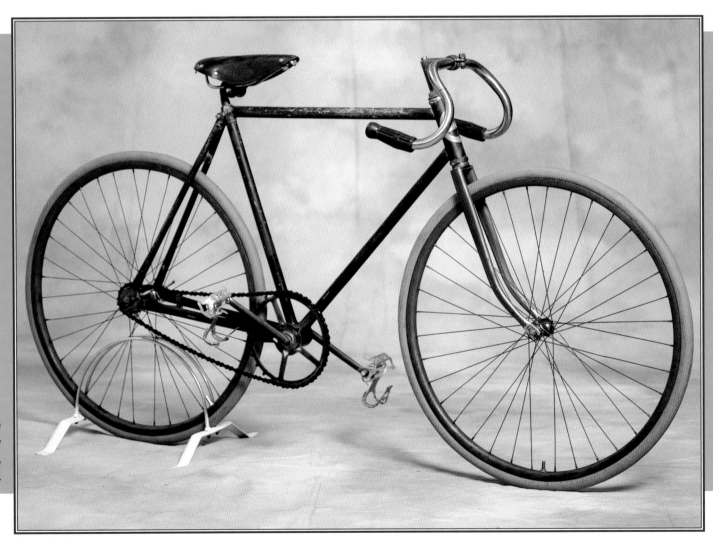

An early Pierce Racer. Made by Pierce Cycle Co., Buffalo, NY.

designed were called "Zimmys," and they were high-quality cycles with state-of-the-art designs in gearing and framework. Ironically, by the time Zimmerman started promoting his bicycles, the racing world was beginning to embrace a new wave of racers who would ultimately eclipse Zimmy's achievements.

One racer who separated himself from the pack was Marshall Walter Taylor, a young man from Indianapolis who would captivate the bicycle racing world as Major Taylor. Taylor was the antithesis of Zimmerman in that he was motivated by clean living and a burning love for training. But most significantly, Taylor stood out from other racers of his time because of the color of his skin. As an African-American, Taylor had to stand up to more than just the challenge of his opponents on racing days. Jim Crow laws, prejudice and refusal of membership into the League of American Wheelmen were all factors working against Taylor's meteoric rise to stardom at a time in history when color

barriers prevented black athletes from competing professionally in almost every sport.

He started his career on bicycles as a trick rider, which gave him considerable advantages later in his racing career, as he often needed to employ uncharacteristic maneuvers to escape "pockets" and improve position. Early on, Taylor competed in six-day races before working his way up the professional circuit, and by 1897, he was probably the strongest rider in the country. Because he could not travel down south with the other riders out of concern for his safety, Taylor was not able to maintain his national ranking, however, and his place in the rankings slipped as a result. That is not to say that his troubles were over when racing in the north. Taylor was often the victim of racing conspiracies amongst the other riders who often went out of their way to box him in, sacrificing their own chances of winning to prevent Taylor from gaining the lead. They did this for a piece of the winning purse, and Taylor referred to them as "pie biters." A brilliant strategist,

A group of early bicycle cyclometers.

Taylor would feign fatigue at times to soften expectations of an attack. He would also allow himself to be intentionally pocketed, only to emerge unexpectedly, catching the other racers by surprise. In one example of skills honed from years of trick riding, Taylor was racing against Edmond Jacquelin in France when the two riders jockeyed for the rear for drafting position, circling the track at a near crawl so that one rider would ultimately have to take the lead or simply fall from his bicycle. They both came to a standstill at the top of a bank, when Taylor began to pedal his bicycle backwards. Jacquelin seemed to respect and appreciate Taylor's feat, assumed the lead, then surrendered it in the sprint to the finish—a fate many racers of the time experienced down the final stretch against Taylor.

Taylor set world records in the shorter distance races, but he was so strong a rider that he was able to win 25-mile races as well. He eventually earned a sponsor, Waltham Manufacturing Company, which made lightweight racing bikes, and he began to race on Waltham's "Orient Chainless," an expensive chainless bicycle—a smooth and expensive cycle—that ultimately did not fare well among the masses.

Major Taylor traveled abroad with good success and good reason. The Europeans were more tolerant of black athletes, and Taylor competed all over the world—from Holland to Australia. On return from one trip overseas, he was welcomed by Teddy Roosevelt, who praised him effusively for his performances abroad.

Despite the fact that the L.A.W. and other cycling groups, such as the National Cycling Association,

took measures to exclude Taylor from their organizations, the devout Baptist still managed to endear the public to him and elevate the sport of bicycle racing to new levels. In his autobiography, *The Fastest Bicycle Rider in the World*, Taylor wrote about his life in racing:

"In closing I wish to say that while I was sorely beset by a number of white riders in my racing days, I have also enjoyed the friendship of countless thousands of white men whom I class as among my closest friends. I made them in this country and all the foreign countries in which I competed. My personal observation and experiences indicate to me that while the majority of white people are considerate of my people, the minority is so bitter in their race prejudice that they actually overshadow the goodwill entertained for us by the majority."

Major Taylor

The end of the nineteenth century saw bicycle racing at its zenith in popularity, with colorful and heroic racers like Major Taylor and A.A. Zimmerman at every turn. But at the beginning of 1900s, the bicycle craze began to decline, and with it, the public's interest in racing waned. It was a cool-down that didn't last long, however, as bicycles were here to stay and racing ultimately reemerged with even faster, sleeker designs.

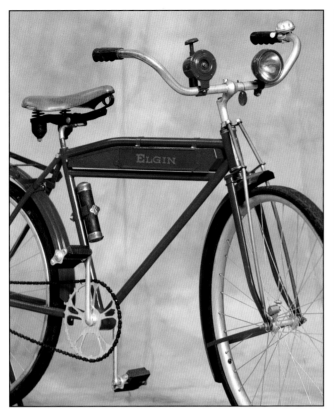

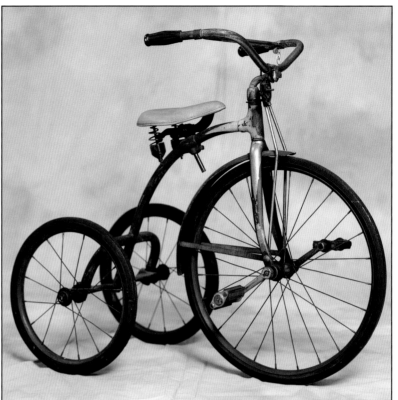

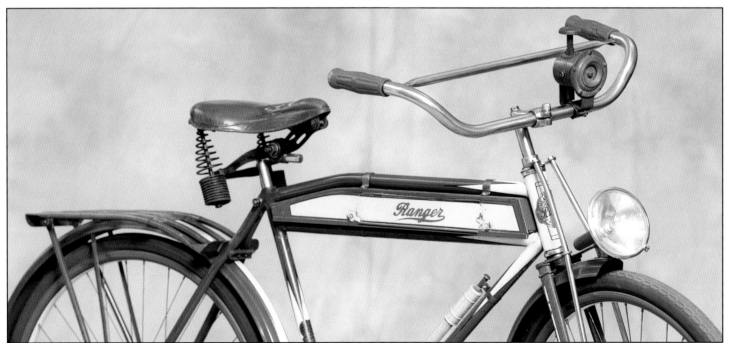

The Twentieth Century Bicycle

By the turn of the 20th century, it has been said by historians that the bicycle craze was complete. The age of the automobile, they say, was bound to eclipse the growth of the bicycle industry, sweeping horses and carriages aside, only to begin a new kind of craze that altered the course of modern lifestyle. In fact, that wasn't the whole story. Competition and consolidation changed the bicycle business drastically, leading to price wars among manufacturers to claim market share. And because of the boom in the nineties, the business simply could not sustain the kind of growth it had enjoyed in the previous decade.

Bicycles were being sold not just in specialty shops anymore, but in drug stores and general stores, and the prices declined steadily. Add to that the proliferation of perfectly good used bicycles flooding the marketplace, and before long, some of the biggest names in bicycle manufacturing were either going bankrupt or being bought by other companies. Rather then continue the charade of selling bicycles well above actual cost, many manufacturers felt their only chance of survival hinged on producing high quality bicycles to be sold at low cost en masse through department stores and other non-boutique shops. Naturally, the price of bicycles dropped dramatically, and custom and independent bike shops were forced out of business.

Bicycles which had sold for over $100 only months before were now retailing for about $25 in the country's largest department stores. It didn't take long for some manufacturers to figure out that they could make more profit by providing cheaper bicycles to these stores, and before long, the market became saturated with bicycles of dubious quality. It was estimated that over a million bicycles were sold in 1900, and yet just four years later, less than a quarter million were sold. The automobile would soon dominate the roadways, and the writing, many felt, was on the wall, at least in the United States. In Europe, the bicycle industry continued to thrive.

In spite of the bicycle slowdown, inventors and manufacturers continued to make important contributions and improvements in design and production.

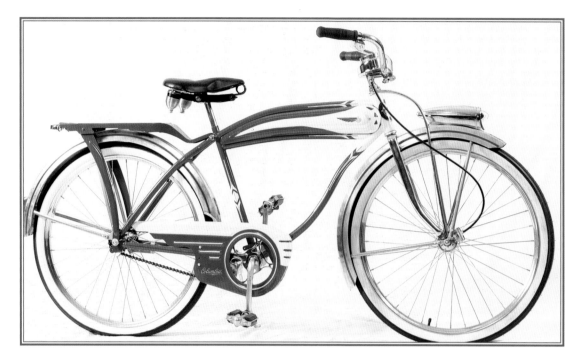

Bicycle makers had, during the boom, developed sophisticated mechanical elements such as ball bearings, variable gears and light, durable metal frames. They improved and perfected pneumatic tires and many of these designs were carried over to the automobile industry, sometimes by bicycle designers themselves, who were in the forefront of automobile engineering. One such mechanic was Henry Ford, who abandoned the bicycle business at the turn of the century to start his new business, the Detroit Automobile Company. The rest, as they say, is history.

The Boy's Columbia Superb is equipped with horn tank, fender light, clock, speedometer, milage gauge, rear carrier, and chain gaurd.

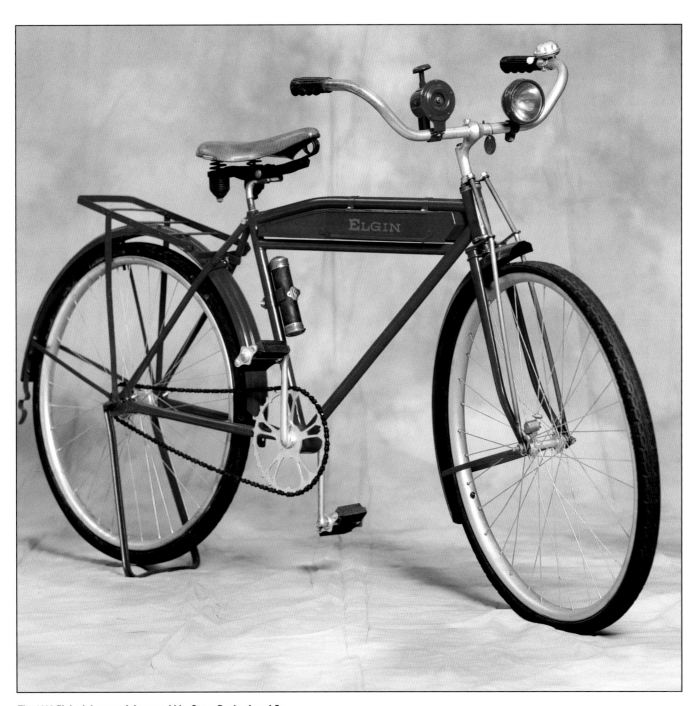

The 1920 Elgin deluxe model was sold by Sears Roebuck and Co.
and was loaded with horn tank, claxon horn, headlight, front fork truss bar,
battery holder, rear carrier, rear wheel stand and front and rear fenders.

Ignaz Schwinn, a German bicycle maker who lived in Chicago started his company with his partner, Adolph Arnold just before the turn of the century. Arnold, Schwinn and Company saw the coming of the automobile boom and experimented briefly with carriage prototypes, but decided to put their focus on quality bicycles—mostly by improving the frames. Schwinn would later return to advanced technology, producing motorcycles for the United States military, as well as engines for airplanes after World War I. But it would be his bicycles that would most influence American culture. He survived the bicycle bust of the first part of the twentieth century by riding the wave of enthusiasm over motorcycles and producing some of the finest models.

The 1910s and '20s were fairly quiet decades for bicycle manufacturers, though. Bicycles continued to be produced, but at just a fraction of the rate enjoyed at the end of the nineteenth century. Women were riding more, and bicycles for children became a popular purchase, especially around Christmas. Fine

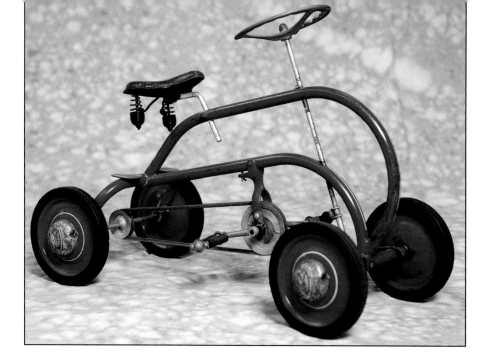

The four-wheel velocipede, patented in 1941 by E.J. Weller, Jr., of Milwaukee, WI was referred to in patent papers as an "improved velocipede."

bicycles were still being made and produced, but companies were leaving the business at a steady rate, as supply exceeded demand and prices dropped drastically. For the most part, the bicycle's availability in dime and department stores made cheaply made, inexpensive bicycles more the norm. A bicycle catalog from 1914 touting the Elgin King gives some idea of what manufacturers faced at the time. The Roadster Model was advertised for $14.95 and the advertising copy read as follows:

A Splendid Reputation—Won and Upheld by Reliable Service

Our Elgin King Bicycle has been prominent in bicycle history since the early cycling days. Today it is even a better bicycle than when it sold for $100.00.

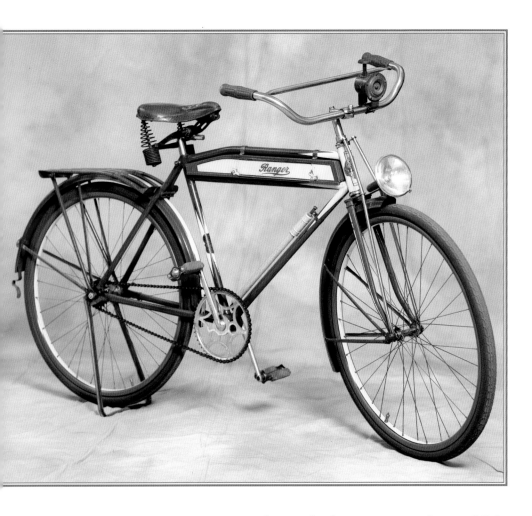

followed put an end to Schwinn's motorcycle production business, but he was about to enter a period of growth even he could not have imagined.

As automobile sales predictably suffered, the bicycle enjoyed a revival. Much of the revival centered around the replacement of single tube tires, which needed to be patched upon punctures—a fairly frequent occurrence for a bicycle owner. In 1927, the balloon tire made its debut on bicycles. Goodyear had been developing such a tire for automobiles, and when bicyclists got a taste of double-tube tires that were easy to fix, there was no turning back. The Arnold, Schwinn & Co. immediately recognized the importance of this new tire and went to great lengths to inform the world that their bicycles would be incorporating the latest tire technology. Before that, tubeless tires were notorious for obtaining irreparable damage to them, fueling the replacement market for tires, but ultimately hurting bicycle sales.

Motorcycles made the newspapers by establishing speed records bicycles simply could not compete with. Americans, for the most part, were prospering and caught up in the progress of the automobile. Schwinn continued to make and sell motorcycles, but another cataclysmic event forced his hand. The 1929 market crash and the coming Depression that

Schwinn traveled overseas to Germany, where bicycles and motorcycles had been using balloon tires

with great success, and he returned convinced that the Europeans were onto something. He designed his frames to be sturdy enough to carry the more cumbersome balloon tires, and by the early 1930s, the bicycle industry was about to experience a tremendous pendulum swing back to a boom. The 1933 Schwinn B-10E was the first bicycle to use balloon tires and parents immediately recognized that their lives would be much easier if they weren't constantly devoted to fixing flat tires. The B-10E was a cruiser that quickly and quietly made a statement.

At first, there was skepticism. Balloon tires made the bicycle considerably heavier. And if the air pressure wasn't adequate enough, the bicycle performed sluggishly. They were also more expensive and many chain stores refused to carry them at all. But if used properly, balloon-tired bicycles were superior to any other bicycles on the market, and smaller, independent bicycle stores began to prosper by selling them. Within just a few years, it was nearly impossible to find a new bicycle sold without balloon tires,

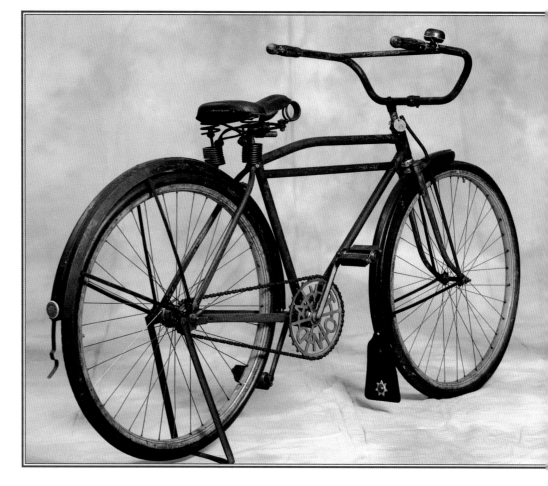

and Schwinn had established itself as the leader in bicycle manufacturing in America.

The following year in 1934, Schwinn announced a new Streamline Design, which promised to deliver aerodynamic features and qualities used in airplane design. The Aerocycle had curved steel tubes, a headlight, and a camelback frame that looked strikingly

The 1915 Dayton Bicycle is outfitted with long motorcycle type handlebars, double top bars, a truss bar front fork, front and rear fenders, a rear carrier and rear wheel bicycle stand. Made by Davis Sewing Machine Co., Dayton, OH.

like a motorbike without the motor. There wasn't a child in the country that didn't have dreams of riding one, and Schwinn promoted the bicycle as if selling a dream. Children too young to ride a motorcycle or automobile were happy enough, for the time being, to ride and be seen riding an Aerocycle. Accessories such as horns, speedometers, front brakes, and even built-in compartments created a generation of young riders who became conscious of gadgetry.

The Clown Bucking Bronco horse bicycle has an offset rear axle that creates the bucking bronco ride.

Before long, nearly every bicycle manufacturer was developing and producing its own line of Aerocycles. By 1936, Americans purchase over one million bicycles. However, it was estimated that most of the bicycles were going to children, and manufacturers such as Schwinn and Columbia were determined to make bicycles for adults as well. The Europeans were well out in front in this area, as their lighter, more practical bicycles were popular in countries like England and France. Ironically, another bicycle maker in Chicago, Emil Wastyn, a Belgian immigrant and one of the top bicycle mechanics in the world, was already making bikes with what he felt was superior European technology. Schwinn and Wastyn then set out to make a bicycle that would capture the qualities of European racing bikes, and appeal to a market beyond children in the United States. The team came up with the Schwinn "Paramount," which they set about promoting as the greatest, fastest bicycle ever built.

The Floating Bicycle

The Floating Bicycle leaves the rider chest deep in the water. The front air tank has two handles to operate the front steering rudder.

The sprocket gear turns the propeller shaft. Four feet of water is needed to ride the cycle while air tanks keep the cycle afloat. Patented

May 17, 1917, the cycle was made by Paul Kraemer of Jersey City, NJ.

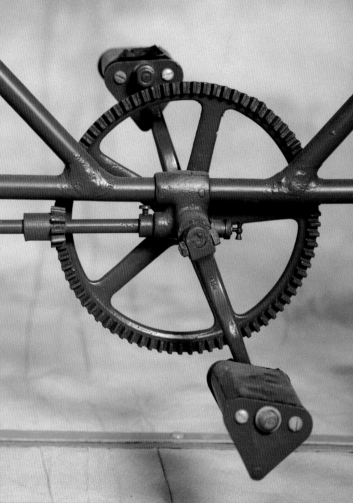

Their search for the perfect promotional stunt led them to one Alf Letourner, the infamous paced rider and six-day competitor. In the spring of 1941, Schwinn outfitted a Paramount with an unheard of front sprocket to create a gear ratio of 9 to 1, making it the highest geared bicycle ever made at 252. Riding in front of Letourner would be another racer, Ronney Householder, who drove a specially designed mini racing car with an airfold that enabled Letourner to draft behind it as he built up speed. The two barreled down a flat stretch of road in southern California. After a few tries, Letourner was able to cover a mile in 33.05 seconds, establishing a new record speed on a bicycle of 108.92 miles per hour. The promotional event garnered a great deal of publicity for Schwinn and the Paramount.

"As a kid I had a dream—I wanted to own my own bicycle. When I got the bike I must have been the happiest boy in Liverpool, maybe the world. I lived for that bike. Most kids left their bikes in the backyard at night. Not me. I insisted on taking mine indoors and the first night I even kept it by my bed."

John Lennon

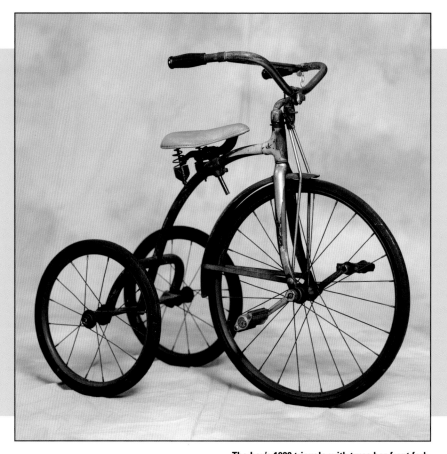

The boy's 1920 tricycle with truss bar front fork, cross bar on long handlebars, and foot steps on rear axle.

The 1915 Columbia Superb shaft-drive bicycle with a coaster brake drive.

Unfortunately, World War II was on the horizon, and most bicycle manufacturers would be called upon by the government to produce war-related materials instead of bicycles. However, the war did not set back the bicycle industry—rather it simply placed things on hold for a while. Bicycles remained popular, especially in Europe, as lightweight bicycles captured the public's imagination. At the end of the war, companies like Columbia, Schwinn and Raleigh in England began making up for lost time, producing bikes at a dizzying pace. And before long, bicycles would indeed become part of everyday life for many, the same way automobiles were for others.

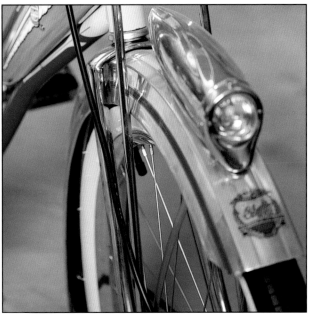

The Modern Bicycle

After World War II, many servicemen returned to America having seen Western Europe's fascination with bicycles first-hand, and they were intent on becoming riders themselves. While American children had been the target market for manufacturers in the United States, the European bicycle makers had been focusing on the adult population of Europe. One of the features of European bicycles that caught the fancy of adult riders was the proliferation of thin-tired bikes. American makers had been producing larger balloon tires on bicycles—a trend that would continue through the 1960s. But the thin-tired bicycle—preferred by European adults—would soon make their mark in the United States. The most popular bicycles in Europe were made by Raleigh in Great Britain, and after the war, tens of thousands of the bicycles were exported to America. The British invasion caught most U.S. manufacturers off guard, allowing Raleigh to get its foot in the door in the American market. In fact, Raleigh remained a presence in the U.S. for decades, making some of the most popular bikes on the market. This was a great disadvantage for American companies, as import tariffs had yet to be established to effectively level the playing field. However, it didn't take long for American companies like Schwinn and Columbia to begin marketing lightweight bikes for adults as well,

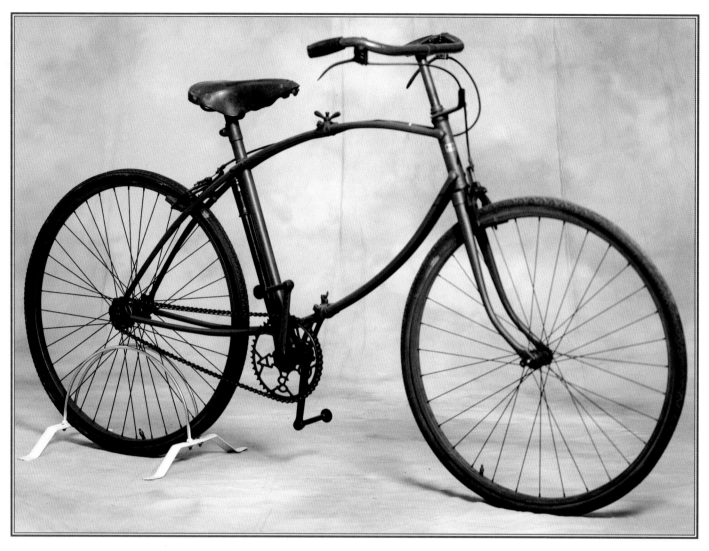

and before long, the bicycle—which had experienced difficult times during the Depression and World War—became popular again. If Raleigh was able to capture a significant part of the adult market, American bike makers, which had targeted many of their designs toward children, were about to receive a stroke of luck not even the most sophisticated designer could have foreseen. America, following World War II, had entered a full-blown Baby Boom. Millions of children were born into middle-class families, creating a potential market that the American bicycle industry was primed and prepared for. Perhaps no company was as ready as Schwinn. In 1949, Schwinn introduced its Black Phantom model—a 26-inch boy's bicycle available in black with red trim. With a sleek, curved, cantilever frame,

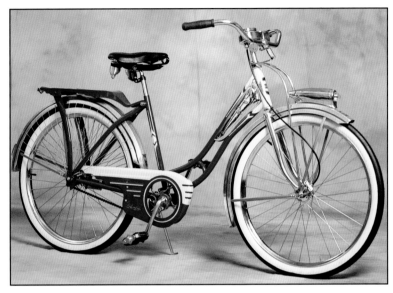

The 1941 Girl's Columbia Superb.

the Black Phantom was not light. It weighed about 80 pounds, but was designed to look much faster, and young American boys embraced the streamlined bicycle, making it one of the most popular ever sold in the United States. Interestingly, early Phantoms were outfitted with a key-locking front fork which was designed to prevent theft. Schwinn also included a written guarantee against theft which covered the owner's first year with the bicycle—a guarantee that clearly added to the mystique of the Phantom. Later Phantom models would appear in other color schemes (red and green), some with slightly smaller whitewall balloon tires. It came with Schwinn expander brake hubs in both the front and rear, as well as a deluxe glass reflector on each wheel. But the amount of chrome on the Phantoms was eye candy for young boys, who yearned to ride on something that so elegantly resembled their vision of a motorbike. While streamlined bicycles captured the imaginations of boys after World War I, some manufacturers looked into the past as well as the future for

"Let me tell you what I think of bicycling. It has done more to emancipate women than anything else in the world. It gives a woman a feeling of freedom and self-reliance. I stand and rejoice every time I see a woman ride by on a wheel ... the picture of free, untrammeled womanhood."

Susan B. Anthony

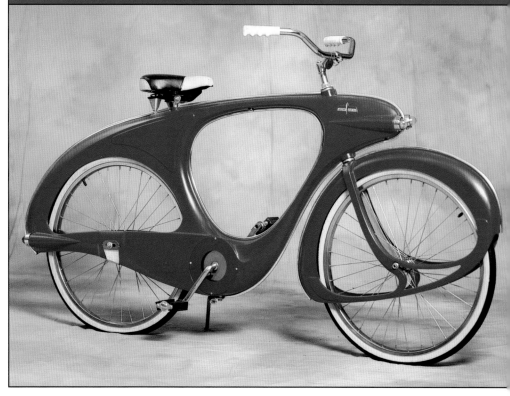

A Bowden Spacelander has a fiberglass frame.
Made in 1959 and 1960, it had a unique and interesting design.

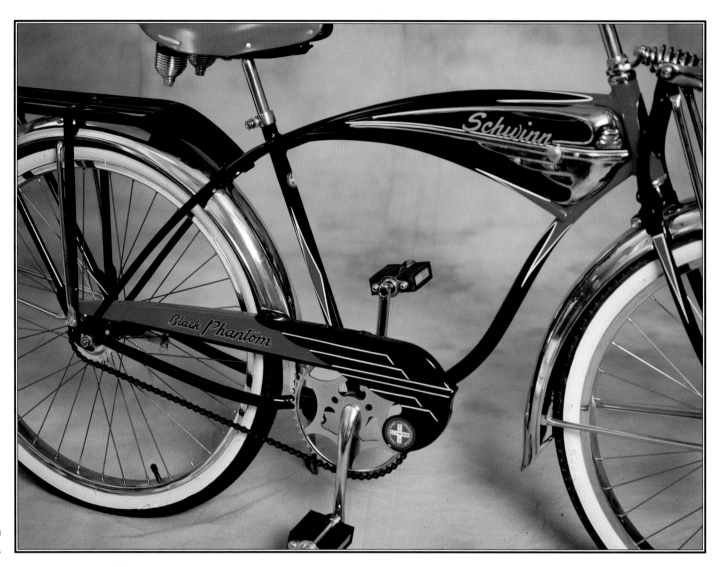

inspiration in bicycle designs. The 1950s saw many bicycle gimmicks, such as the Huffman Radiobike—a bicycle made in Dayton, Ohio that enabled a rider to tune into a radio while they rode. It did not work as well as advertised, but it represented an electronic gadget besides headlights that some children found irresistible. Some bicycles, such as cowboy bikes—most notably DPH's "Hopalong Cassidy" had a foot place firmly in the past—while some manufacturers looked more toward the future in bicycle design.

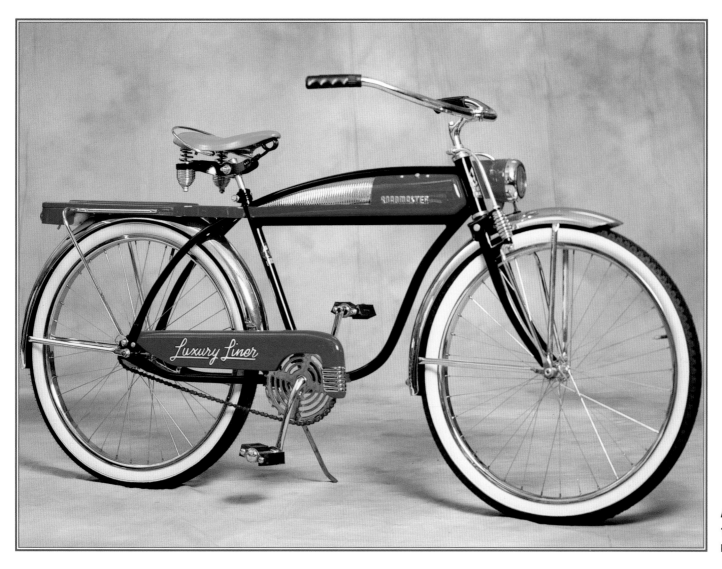

Americans became obsessed with supersonic flight, as well as space, and the 1960s reflected this fascination in bicycle design.

Fiberglass framed bikes, such as the Bowden Spacelander, weighed less than fifty pounds, but cap-tured more interest from collectors than consumers. The bikes, many felt, were just not practical from a visual point of view. After the Spacelander, which was not a fast bicycle at all, American consumers began to take the speed of bikes seriously, as opposed

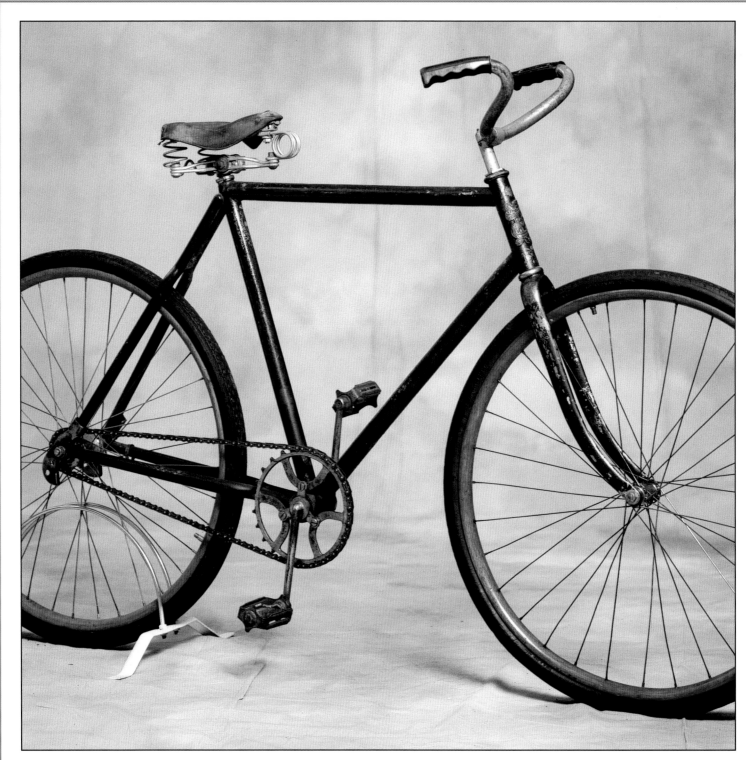

The 1915 Boy's Columbia Superb.

to just the presumption of speed. Bicycles became lighter and many came equipped with thinner tires, two- and three-speed gear systems, and before long, eight-and ten-speed bicycles were readily available on the American market.

In 1962, only seven years after President Eisenhower suffered a heart attack which served to educate the public on the importance of exercise, the President's Council on Physical Fitness was formed. The bicycle became something of an image promoting good health and outdoor activity and the '60s produced yet another bicycle boom. British three-speeds were the most popular at the start of the decade, but by the end, ten-speed "derailleurs" dominated the market. Ironically, derailleurs had been in existence at the end of the nineteenth century, and despite some popularity in Europe, they never captured the American public's imagination until decades later. Schwinn had tried several times during the '50s and early '60s to make a go of the derailleurs, to no avail. But by the end of the decade, racers and casual cyclists were

"I suppose that was what attracted me to the bicycle right from the start. It is not so much a way of getting somewhere as it is a setting for randomness; it makes every journey an unorganized tour."

Daniel Behrman

hooked on ten-speeds, and they've never looked back. Racers and touring bicycles formed the foundation of the bicycle boom that followed the 1960s. Bicycles flourished during the '70s fitness craze that swept America out onto the roads, as cycles were being produced at an astonishing rate once again. In fact,

the '70s was a decade that seemed designed for the growth in bicycles. In 1970, Earth Day became a cause that increased awareness regarding the consumption of natural resources and the problems of air pollution. Bicycles became environmentally sound solutions that were embraced by Americans young and old. By 1973, fuel shortages, oil embargoes and the growing cost of gasoline helped grow the

Made in Holland, the 1970s Union Bicycle with a small front steering wheel and unusual handlebar arrangement is very short, light, and easy to peddle.

number of citizens willing to take to the bicycle. All in all, bicycles were back in America. Around the world, bikes became popular for different reasons, especially in China and other countries that used them as a matter of practicality rather than fashion. Today's bicycles are lighter and more aerodynamic then ever before, as science and computers have enabled designers to produce cutting-edge technologies in the quest for more perfect machines. Yet collectors are quick to point out that racing bicycles simply have not changed very much in over a century. Their point is that there were great minds working on self-propelled vehicles ever since Baron von Drais first demonstrated his remarkable Draisines in the early nineteenth century. The sweat and toil of men like von Drais, Lallement, Michaux and Pope produced a remarkable array of Boneshakers, Velocipedes, Ordinaries, Safeties and Bikes for collectors to marvel over. And perhaps as we examine the bicycle's past, it will only make us wonder what the future may bring!

An Alenax Mountain bicycle made in the early 1990s.

Chapter Opener Photo Identifications

Title page
Page 2
(Top left) **The Donaldson Jockey Cycle, made by J.E. Donaldson Mfg. Co., Kansas City, MO. Propelled by up and down foot levers connected to the offset rear axle.**

(Top right) **1890's Three Wheel in-line cycle with wood rims and handlebar. The frame is part wood and part metal tubing. The 28-inch drive wheel is one inch off the ground when walking the cycle. As you mount the bicycle and settle into the saddle, the two piece tubing behind the seat with a long spring inside compresses and the wheel makes contact with the ground to start peddling. Maker unknown.**

(Bottom) **The Boy's Columbia Superb is equipped with horn tank, fender light, clock, speedometer, milage gauge, rear carrier, and chain gaurd.**

Chapter One
The Beginnings–Page 12
(Top left) **Early footlever drive child trike.**

(Top right) **Very early French horse tricycle. Hand cranks connected by chain to rear axle.**

(Bottom) **Thirty miniature bicycles made exactly to scale of the originals by a prisoner of war in Belgium in the early 1940s.**

Chapter Two
Velocipedes and Boneshakers–Page 24
(Top) **1884 Rudge Rotary Tandem Tricycle has a 48-inch drive wheel, two 20-inch steering wheels and double rack and pinion steering. Either rider can operate the steering and brakes.**

(Bottom left) **1866 Boneshaker made by C.L. Brownell Co., Bedford, MA.**

(Bottom right) **Old Boneshaker made by E.B. Turner and Co. of England.**

Chapter Three
The Ordinaries and Safeties–Page 38
(Top left) **Highwheel bicycle rider on barrel of cap gun. When rider is pulled back on the barrel, pull trigger and rider goes to the end of barrel, flops over and explodes cap.**

(Top right) **Child's chain drive tricycle.**

(Bottom) **An 1879 junior size hard tire safety bicycle.**

Chapter Four
Tandems, Sociables, and Tricycles–Page 52
(Top left) **Child's Early Tricycle has steering handles on each side, which control the rear steering wheel. The two foot levers connected by leather straps to the offset axle propel the tricycle forward.**

(Top right) **Child's tandem chain drive tricycle with a hand brake at the front wheel.**

(Bottom) **1905 Punnett Companion side-by-side bicycle. Made by Punnett Cycle, Co., Rochester, NY.**

Chapter Five
The Booming Nineties–Page 68
(Top left) **The 1893 Boy's Elliott Hickory with wood wheels and spring-action front fork.**

(Top right) **The 1896 Bentwood Bicycle's entireframe is made of one length of wood which is bent to shape. The ends were split in half to create the rear forks.**

(Bottom) **1898 Wolff American Duplex Tricycle. Made by Wolff and Company, Limited, NY.**

Chapter Six
The Racers–Page 88
(Top) **An Alenax Racing bicycle. Made around 1990, it has a unique transbar power system with part chain and part lever action drive.**

(Bottom left and right) **Arthur A. Zimmerman was the world's first bicycle racing champion. He held the championship many years during the 1880s and '90s. When he retired in 1895, he opened the Arthur A. Zimmerman Cycle Co. in Freehold, NJ, and manufactured several models of the Zimmy bicycle.**

Chapter Seven
The Twentieth Century Bicycle–Page 104
(Top left) **The 1920 Elgin deluxe model was sold by Sears Roebuck and Co. and was loaded with horn tank, claxon horn, headlight, front fork truss bar, battery holder, rear carrier, rear wheel stand and front and rear fenders.**

(Top right) **The boy's 1920 tricycle with truss bar front fork, cross bar on long handlebars, and foot steps on rear axle.**

(Bottom) **The Deluxe Ranger, made by Mead Cycle Co. of Chicago, IL., came complete with a horn tank, head light, claxon horn, air pump, rear carrier, rear wheel stand and front fork truss bars.**

Chapter Eight
The Modern Bike–Page 116
(Top) **The 1943 Schwinn Black Phantom.**

(Bottom left) **The 1941 Girl's Columbia Superb.**

(Bottom right) **An Alenax Mountain bicycle made in the early 1990s.**